Th
re
au

e Most Popular
A Exhibition Ever!

PARTICULAR BOOKS

UK | USA | Canada | Ireland | Australia
India | New Zealand | South Africa

Particular Books is part of the Penguin Random House
group of companies whose addresses can be
found at global.penguinrandomhouse.com.

Penguin
Random House
UK

First published 2017
001

Designed by Tom Etherington
Printed in Italy by Graphicom

A CIP catalogue record for this book
is available from the British Library

ISBN 978–1–84614–963–4

For all their support and hard work, I would like
to thank: my wife Philippa Perry, everyone at The
Serpentine Galleries, the team at Victoria Miro,
Adam Lowe and Blanca Nieto at Factum Arte,
Charles Booth-Clibborn and Florian Simm
at Paragon Press, Neil Crombie and Swan Films,
AB Foundry, Paupers Press, Pangolin, Bikefix,
Petor Georgallou, Battistinis Custom Cycles, Helen
Conford and all at Penguin Books, Jacquie Drewe,
Karolina Sutton, Eric Great Rex and Jennifer Gill.

Grayson Perry

The Most Popular
Art Exhibition Ever!

Grayson Perry

PARTICULAR
BOOKS

The Most Popular Art Exhibition Ever!

Grayson Perry

The title of an exhibition is usually the last thing I think of, often only after the gallery curator has nagged me to come up with something. This time I thought of the title before I had made most of the artworks. It made me laugh, and slightly nervous laughter is the reaction most art world people have to it. Why is that? What is unsettling about an exhibition boasting about being popular?

In 1937 the Nazis organized an exhibition called *Entartete Kunst*, meaning *Degenerate Art*. The idea was to show that Modernism was a conspiracy by people who hated German decency. Visitors were encouraged to see Modernist artists as Hitler saw them: as 'incompetents, cheats and madmen'. The exhibition included some of the greatest German artists of the twentieth century: George Grosz, Paul Klee, Kurt Schwitters and Ernst Ludwig Kirchner. Over two million people visited the show, twenty thousand a day. It was one of the most popular exhibitions of all time. I'm not sure what proportion of those visitors went to the exhibition to mock the art and how many went to enjoy what today would be a coach-party blockbuster, but *Entartete Kunst* surely did nothing to soften the art world's suspicion of popularity.

It's not just the association of popularity with populism and mob politics that provokes unease in some art lovers. Popularity also threatens an important part of art's appeal – its exclusivity. When I left art college in 1982 art felt like a messy amateur business of academics, poshos and enthusiasts – a cultural ghetto of awkward bohemians doing inexplicable things. Part of the allure of attending an exhibition private view was that it felt like entering an exclusive club – the club of people who 'got' art. The art world seemed like an unspoiled folk culture, thriving but untainted by the grubby attention of the mass media and celebrity. Then along came the nineties and the art world exploded. Charles Saatchi, the YBA's, the Turner Prize, Tate Modern and the Frieze art fair meant that contemporary art became, dare I say it, popular. Now hundreds of London art galleries are thronged with young trendies taking selfies in front of the art and posting them on Instagram. The only people left in Britain who seem to feel that contemporary artists are 'incompetents, cheats and madmen' is a certain right-wing newspaper.

There are two metrics that hold weight in the art world. One is auction price: how much in cold cash someone is prepared to pay for a particular piece by a particular artist. The other is visitor figures – how many people go to see certain exhibitions. Some artists have often taken the self-designated moral high ground by claiming not to care about either of these measurements of success. Art for them exists on some inhuman, ethereal plane with no need for an audience, or money. I'm not one of them.

Every year the publication of the art business, *The Art Newspaper*, produces a special supplement dedicated to visitor figures. It lists the top one thousand shows in descending order of number of visitors per day. The best attended gallery show by a contemporary artist in 2016 was by Patricia Piccinini at the Centro Cultural Banco do Brasil in Rio de Janeiro with 8,340 visitors per day. Piccinini tops the ranking but is not a particularly well known or expensive artist. This is because there are many factors that skew the statistics: is the show free to enter, how many hours is it open each day, what else is on at the same venue? Even so the two metrics, price and visitor figures, are not unrelated. Curators working in art museums want to stage exhibitions by popular artists to attract footfall in order to justify their public funding. The acclaim of

institutional academics is seen as a papal seal of approval for an artist and thus will attract collectors looking to invest in art history, therefore promoting higher prices in primary and secondary markets. It is a 'virtuous' circle. But in the twenty-first century to call an artist 'popular' still has the lingering aroma of a put-down. To be called popular can be interpreted as meaning you are 'one of those artists who are popular with ignorant people yet reviled by the *cognoscenti*' – for example Jack Vettriano or Thomas Kinkade. I quote Jacky Klein, the writer and art historian, from the introduction to a monograph on my work:

> In December 2003, a TV programme was broadcast live from one of the major events of the British Contemporary art calendar, the Turner Prize. During the show the presenter, Matt Collings, and artist Tracey Emin talked at length about that year's shortlisted artists. When it came to an analysis of Grayson Perry, however, Emin could muster little more than a sardonic grin and the ambiguous comment: 'Grayson is pretty popular with the masses.' When the prize was announced later that evening and, against the odds, Perry had won, Collings's response was less coy: a simple and bewildered, 'Freaky!'

I was awarded the prize that evening by the Pop artist Peter Blake. He was part of an art movement in the 1950s and 60s that used imagery from popular culture, but I'm not sure if Pop artists were really trying to expand the audience for modern art or they had just found the latest way to *épater la bourgeoisie*. Some of them, like Ed Ruscha, Robert Rauschenberg and Jasper Johns, made quite difficult art *using* popular culture, but I'm not sure you would define their *oeuvres* as mass entertainment. Artists often flirt with popularity but seem wary of truly pursuing it. They are happy to play with popular appeal when insulated by ironic quotes but the academic guardians of good artistic taste often view attempts to genuinely increase accessibility to art as 'dumbing down'. Ironically, academia might just be a major cause of contemporary art becoming truly popular.

When I went to art school just 11 per cent of the population went to university. Tony Blair's government wanted half of us to go on to degree level. Now 48 per cent of young people go to uni and pass through the miasmic barrier that affirms membership of the middle classes. Maybe educated taste is no longer as exclusive as it once was. Cheerleaders for culture often cite figures illustrating that more people now go to art galleries than football matches. Galleries agonize over how to widen their audience, but maybe their audience has widened of its own accord. In the 1960s people started taking popular music seriously, but maybe people these days are making serious art popular? This is not an unalloyed good. I don't think I am alone in being nostalgic for a time when art galleries were empty. Art quickly becomes less attractive when you have to queue for a glimpse of it.

Maybe this unease between exclusivity and popularity reflects something fundamental about us humans. We are pack animals who like to belong to a group, yet we also want to feel we have a strong individual identity, which leads to tension. The phrase 'vanity of small differences' has a relevance here: we want to belong to a tribe, a class, a group, yet within that group we need to feel individual so we tend to dislike no one quite as much as those who are almost the same as us. We particularly dislike their taste. We want to feel we are making the consumer choices that give us status as unique, creative individuals, yet we all crave the support of others approving of the same things.

This assertion of identity through cultural choices is tricky because what is exclusive and what is popular constantly shifts. One minute we feel we are on the cutting-edge of taste; the next all our consumer choices seem very predictable and kitsch. The art critic Clement Greenberg defined kitsch as art after the soul has departed. Kitsch is always snapping at the heels of whatever is fashionable and *avant-garde*. The cycle spins in ever-decreasing circles – what used to be kitsch becomes reborn among hipsters as 'vintage' – but now the idea of 'vintage' has itself become kitsch. Every so often we realize that our mental picture of kitsch has become outdated. The cliché of Gran's front room – stuffed with knick-knacks, saccharine pottery animals and copies of *The Hay Wain* set against lurid 70s wallpaper – is increasingly rare, and becoming hip again as a result. 'Hardworking families' these days have aspirations to the modern, with unusual lighting, a kitchen island, a distressed leather sofa and grey window frames. Kitsch in 2017 lives in rooms which like to think they have a minimalist, New York loft, Scandinavian style. Instead of *The Hay Wain* it's an ironic stag's head on an exposed brick wall. A 'dream home' is no longer a cottage with roses round the door, but a glass box as seen so often on *Grand Designs*. One minute we are smug in our vault of cultural capital, the next it's a matching set of middlebrow clichés.

Part of the reason we choose to consume a culture is how it might reflect on our status. We might be someone who attends obscure modern

music concerts or trashy musicals, binges on box-sets or seeks out rarely visited Byzantine churches. We genuinely enjoy these interests and maybe we also like to think we are the 'sort' of person who's into these things. We might happen to mention what art we've been consuming on social media to lodge another little 'cultured person award' in the minds of our followers. These cultural brownie points might not just be about demonstrating an appreciation of 'high' culture. A recent phenomenon is the glorying in 'guilty pleasures', an indulgence of the well-educated post-modernist to illustrate they have the common touch, to show they are still up with youth culture and down with the masses. Maybe they hope a little of the innocent glee of pop culture will rub off on them and show them to possess that most precious of post-modern qualities, authenticity. But maybe one of the uncomfortable realizations for the university-educated culture vulture in contemporary Britain might be, that nowadays, they are the masses. Eeek!

One recent event more than any other has taught us 'over-educated' liberals that we are no longer the rebels, the outsiders, the underdogs, struggling against the ignorant brute of dominant popular opinion. That event is Brexit. Brexit crystallized a chasm in our society that had been forming for decades, probably since the collapse of heavy industry. It is a creeping divide that has cut across traditional political party lines, particularly and most divisively amongst Labour voters. A divide between those with university degrees and those without, those living in the big cities and the rest of the country, those that have benefitted from globalization and those that have suffered from its effects and to a certain extent between young and old, millennials and baby boomers. In 2016 we have had to finally let slip the feeling that we, the middle-aged centre lefties, were the brave freedom fighters protesting against unfeeling politicians and corporate globalization. Now we are 'Bremoaners', protesting against the UK leaving the EU, siding with the international financiers and David Cameron. I think that in our subconscious minds the metropolitan arts, media and education crowd still feel like we are the college scarf-wearing idealists of our youth sticking it to the man, when in the eyes of most Brexit voters we *are* the man.

Artists are often portrayed as mavericks, free spirits at odds with 'normal' society. But maybe naughty artists are no longer weirdo outliers; perhaps they are now cultural operatives reflecting the values and feelings of a majority of the population. In an online straw poll I asked leave and remain voters in the EU referendum which famous people reflected their values. David Bowie featured in the top ten of both sides.

As an artist I have long been interested in the decreasing value of the rebellious stance. The counterculture has always been the perfect R & D lab for capitalism. What starts as a creative revolt soon becomes co-opted as the latest way to make money. As we have seen over the past few years, the hippie free-for-all face of the internet was a mask that soon fell away to reveal a predatory capitalist robot.

I would characterize the art establishment's reaction to challenge as, 'Oh! Jolly good! Rebellion! Welcome in!' Part of the historic recipe of modern art has been revolution, the overthrow of the old order. But what if the ethos of that rebellion is now mainstream? Punks are now pensioners, tattoos are as dangerous as reading *Harry Potter*, a Damien Hirst show is a nice day out with the kiddies. The mutinous subcultural pose is now the norm. The only people who call art shocking these days are lazy journalists. One of the most unsettling gestures in recent British art history was Tracey Emin saying she voted Tory. These days they seem very popular.

Immediately after winning the Turner Prize a journalist asked me whether I was a serious artist or just a lovable character. My response was to say, 'I'm both'. I don't see them as mutually exclusive. Art can be intellectually stretching, significant, moving and fun at the same time. Art heavyweights sometime forget they are part of the leisure industry. People, on the whole, come to art exhibitions *on their day off*. They do not want to feel that they are just doing their homework. Maybe it is time to take the sting out of the word popular.

When I came up with this title – *The Most Popular Art Exhibition Ever!* – I liked it because it chimed with one of my on-going ambitions – to widen the audience for art without dumbing it down. Mainly I liked it because it made me giggle, but popularity is a serious business. Ask any politician.

In a recent poll Leave voters were asked what should now happen in a post-Brexit United Kingdom. The most popular choice was to bring back the death penalty.

Extraordinary Popular Delusions and the Madness of Crowds

Sandi Toksvig

Possibly one of my favourite books was written in 1841 by a Scottish journalist called Charles Mackay. It's called *Extraordinary Popular Delusions and the Madness of Crowds*. I bought it by chance at a flea market in New York. I'd never heard of it but I liked the title and was thrilled that such a fat volume was available for just $1. It's about crowd psychology. Mackay was one of the first to try to understand it. He wrote: 'We find that whole communities suddenly fix their minds upon one object, and go mad in its pursuit; that millions of people become simultaneously impressed with one delusion, and run after it, till their attention is caught by some new folly more captivating than the first.'

There is a story in it that stays with me. I'm not great at finance but I know that no one should invest in anything they don't understand. Back in the early eighteenth century there was a young Scotsman called John Law who inherited money and made more through gambling. He made friends in high places and in particular with the Duke of Orléans, who became Regent of France on the death of Louis XIV. France was in terrible debt and the Duke was meant to be in charge but he had no head for business so he turned to his friend Law.

Among other things, Law conceived a money-making scheme which prominently figured the opening up of the Mississippi valley in Louisiana, then under French control. Law declared that the resulting trade would solve all of France's problems. He launched The Mississippi Company and wildly exaggerated the wealth available in Louisiana. No one checked what he was claiming and the public went mad for shares in the company. From the poorest to the richest everyone had visions of boundless wealth. Mackay writes: 'People of every age and sex and condition in life speculated in the rise and fall of the Mississippi bonds.'

Most of the trades took place in a tiny little Parisian street called Rue Quincampoix. Soon shares were exchanging hands so fast that all the transactions took place outside in the street as no one even had time to go inside a café or bar. According to Mackay, a '...hunchbacked man, who stood in the street, gained considerable sums by lending his hump as a writing-desk to the eager speculators!' Of course, the whole scheme turned out to be soap bubbles – pretty in the light but quick to burst. The company could not sustain itself and collapsed, people were ruined and Law fled Paris.

What happened is understandable. When there are problems the child in all of us wants to believe that we could entrust one person to make things better. A Mary Poppins. It is why populist politics is the land of the platitude. The most successful slogans read like bad greeting cards – there was Obama's *'We are the ones we've been waiting for'* or George W. Bush's excellent *'Real Plans for Real People'* as opposed to all those fake plans for inflatables. My favourite was the Tory party's *'Are you thinking what we're thinking?'* which never worked for me as every time I saw a poster I seemed to be thinking about biscuits.

Slogans might as well say *'I'll keep you safe'* or *'No bad people will get you while I'm in charge'* or *'I'm going to give you money.'* They go straight to that place in us which is needy or greedy or both. No one can actually deliver exactly what we want so the result is that many populist movements are based on rather blatant untruths. Even Donald

Trump, the working of whose mind appears to be a mystery even to himself, cannot have believed that he would build a wall and Mexico would pay for it. Similarly, the Brexit Leave campaign knew perfectly well that leaving Europe did not mean Britain would suddenly have £350 million extra a week to spend on the NHS, yet they carried on driving around in a bus emblazoned with this falsehood. The populist politician builds fabulous castles on sand in the hopes that no one will ever check the foundations.

Personally I like to check things. I like a plan. A map of where I am going. I am a passionate European. Belonging to Europe has kept peace for more than seventy years and that alone would do for me as a reason to stay in the club. My main problem with the referendum was that the British were asked to vote on whether to stay or leave without anyone really having a plan for the latter. It was like inviting a lot of people for dinner without first checking if there was food in the fridge.

The main problem with populism is that it brings death to nuance. The Leave campaign achieved 51.9 per cent of the vote but now treat their win as the greatest of triumphs. The 48.1 per cent 'Remainers' are denigrated as 'remoaners', instead of being seen as what they really are – nearly half the population with serious misgivings about the future. For the Leavers the tide we are on is sweeping the great ship Britannia to greater glories while the Remainers fear they can hear the pounding waters ahead of some great cataract of destruction. It is a disparity of view that bears discussing, but instead we are polarized into binary positions with each side confident they are right and that the opposition is not just wrong, but evil.

The fact that the images Remainers and Leavers sent to Grayson for his work had some overlap reminds us that the world isn't actually the black-and-white place the tabloids might have us believe. There aren't just good guys who are patriots and bad guys who hope the world goes to hell in a handcart. Too much of politics seems to have turned to a sort of gladiatorial contest where complex matters are given a thumbs up or down; where discussion is simplified until it becomes almost meaningless.

The rich detail in this exhibition reminds us to look again; to see the layers and intricacies of each other's view point. We need art that teaches us this. In my bedroom hangs a wonderful painting of a girl in a canoe done by a Danish artist in the early twentieth century. It's painted on the back of a cigar box lid – because in rural Denmark no canvases existed yet – art still found a way out. I also have a piece by a Native American from a school of work known as 'ledger art', when artists painted and drew on paper from old books of accounts because that was all they had. The boring columns of numbers still bleed through the image of a magnificent female warrior on her horse. Both pieces are layered with complexity and story and that is the same gift Grayson has given us in all this work – *Head of a Fallen Giant*, the image of *Our Mother* and the glorious *Battle of Britain* tapestry.

Mackay's book contains many wonderful illustrations but no note of who the artist was. The frontispiece merely states that the book is 'ILLUSTRATED WITH NUMEROUS ENGRAVINGS.' My favourite is listed as 'Humpbacked Man hiring himself as a Table'. It is a portrait of frenzy in which men wave papers and shout as they exchange Mississippi Company shares. All the while one old stooped man stands patiently at the centre letting business be conducted on his back. He is not drawn in by the mayhem. He is the only individual in the crowd, and I love it. I expect he was already excluded in life by many, but after all the shouting was over, he was the only one who did well out of the mania.

Sketches

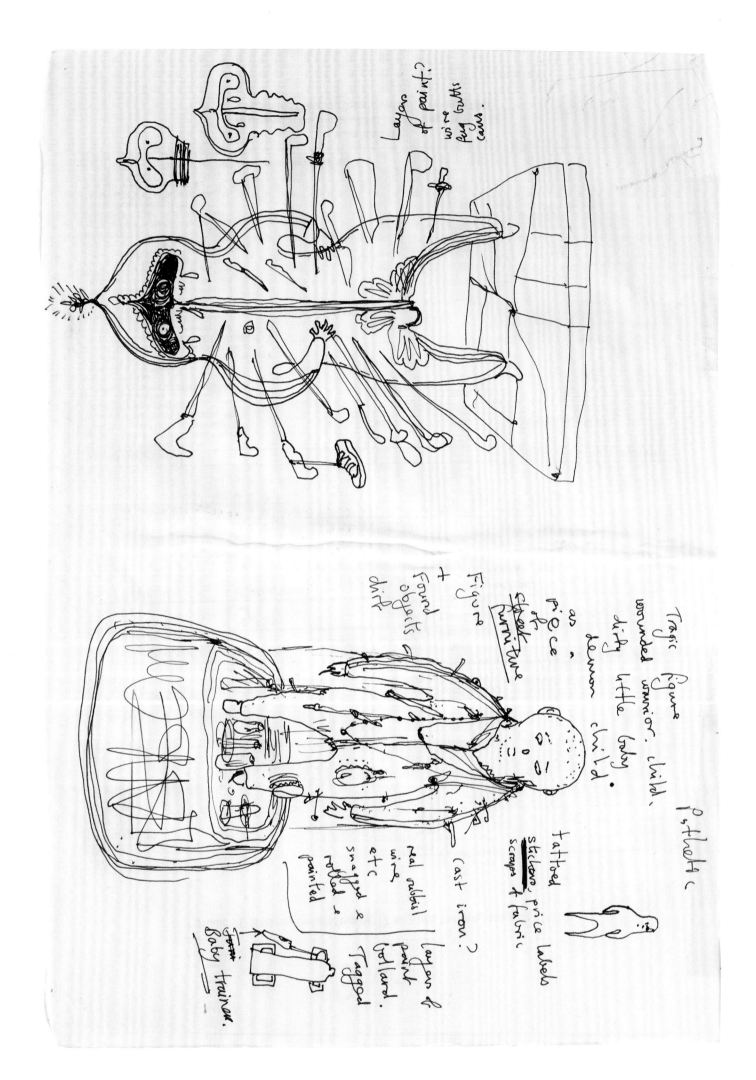

King of Nowhere — This sketch was done on the back of a call sheet while
we were filming *All Man* (my 2016 show for Channel 4) in Skelmersdale.
It was a very direct reaction to the men and the environment they operated in.

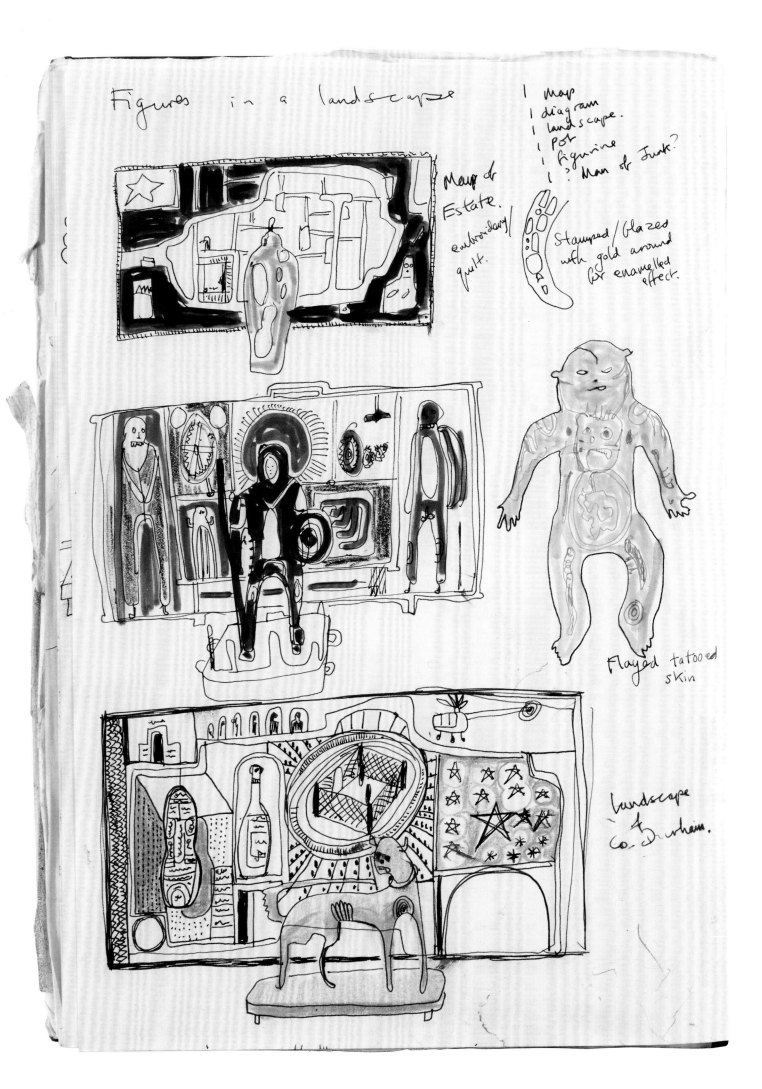

Figures in a landscape

1 map
1 diagram
1 landscape.
1 pot
1 figurine
1 ? Man of Junk?

Map of Estate. embroidery/ quilt.

Stamped/Glazed with gold around for enamelled effect.

Flayed tatooed skin

Landscape Co. Durham.

All Man — Early on I decided I wanted to make one
wall piece and one sculpture for each episode of *All Man*,
an equivalent of man in a landscape.

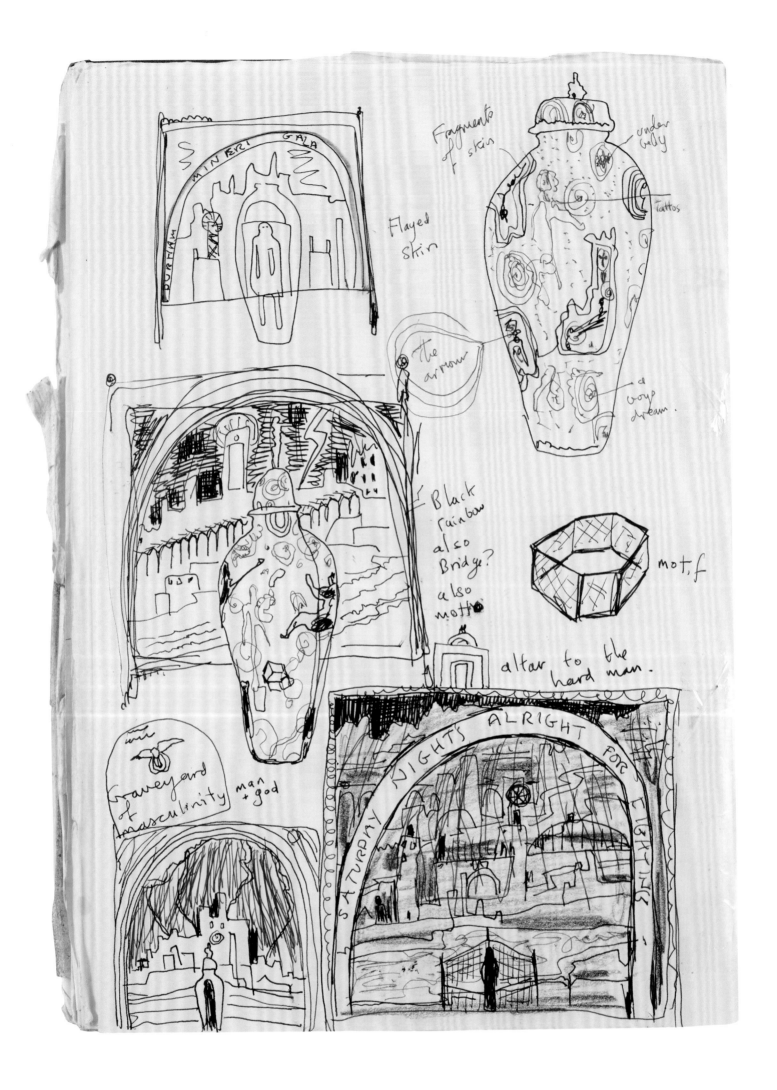

Shadow Boxing — This vase was to be
a funeral urn for outdated masculinity.

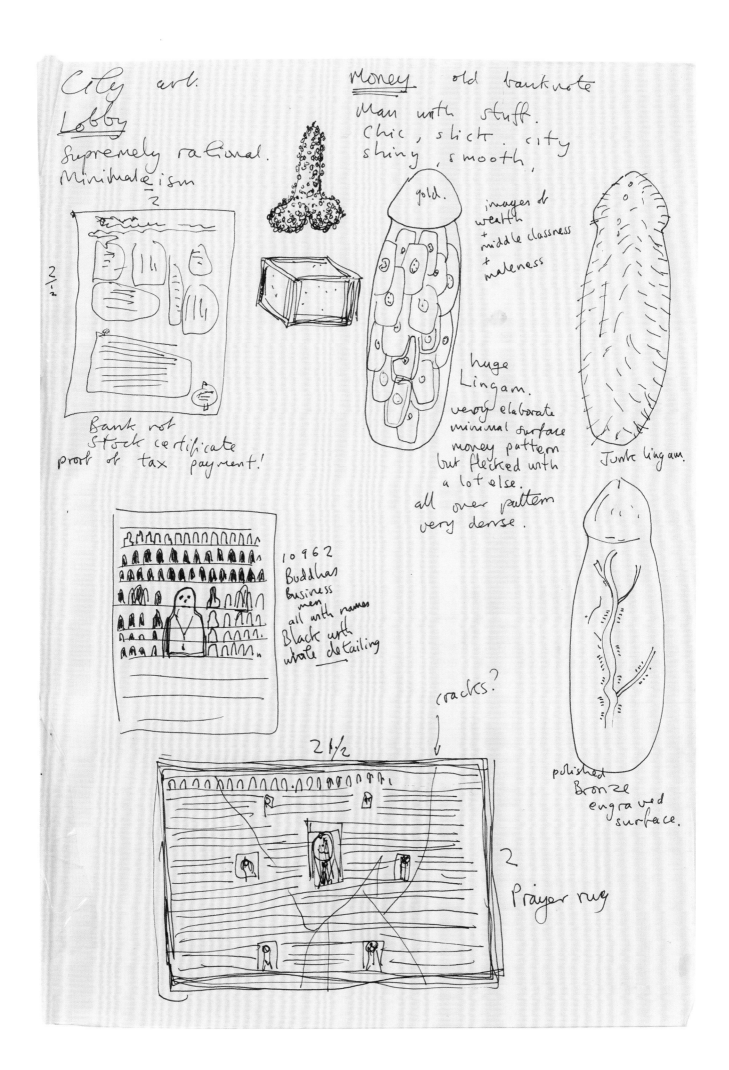

City art.
Lobby
Supremely rational.
Minimal_ism
2

2/-2

Bank not
Stock certificate
proof of tax payment!

Money old banknote
Man with stuff.
Chic, slick. city
shiny, smooth,
gold.

images of
wealth
+ middle classness
+ maleness

huge
Lingam.
very elaborate
minimal surface
money pattern
but flecked with
a lot else.
all over pattern
very dense.

Junk lingam.

10962
Buddhas
Business
men
all with names
Black with
white detailing

cracks?

2 1/2

2

Prayer rug

polished
Bronze
engraved
surface.

Object in Foreground — I wanted to juxtapose masculinity,
finance and the aesthetic of bland spirituality, so I fantasized
a Buddhist lingam in one of those corporate lobbies.

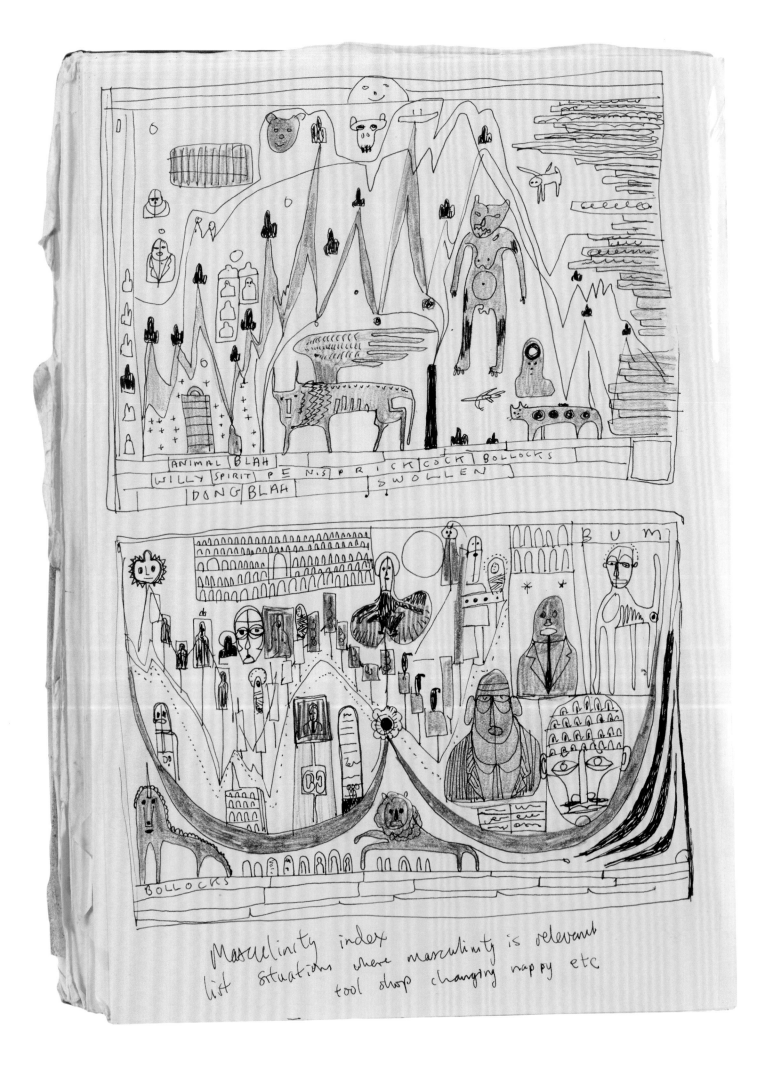

Animal Spirit — I struggled to find a source of imagery that worked
for me in the city as it was all men in suits in front of computers in
boring buildings. Then I learnt about Japanese candlestick graphs
and the associated symbols which inspired something more heraldic.
I was also influenced by old stock certificates and bank notes.

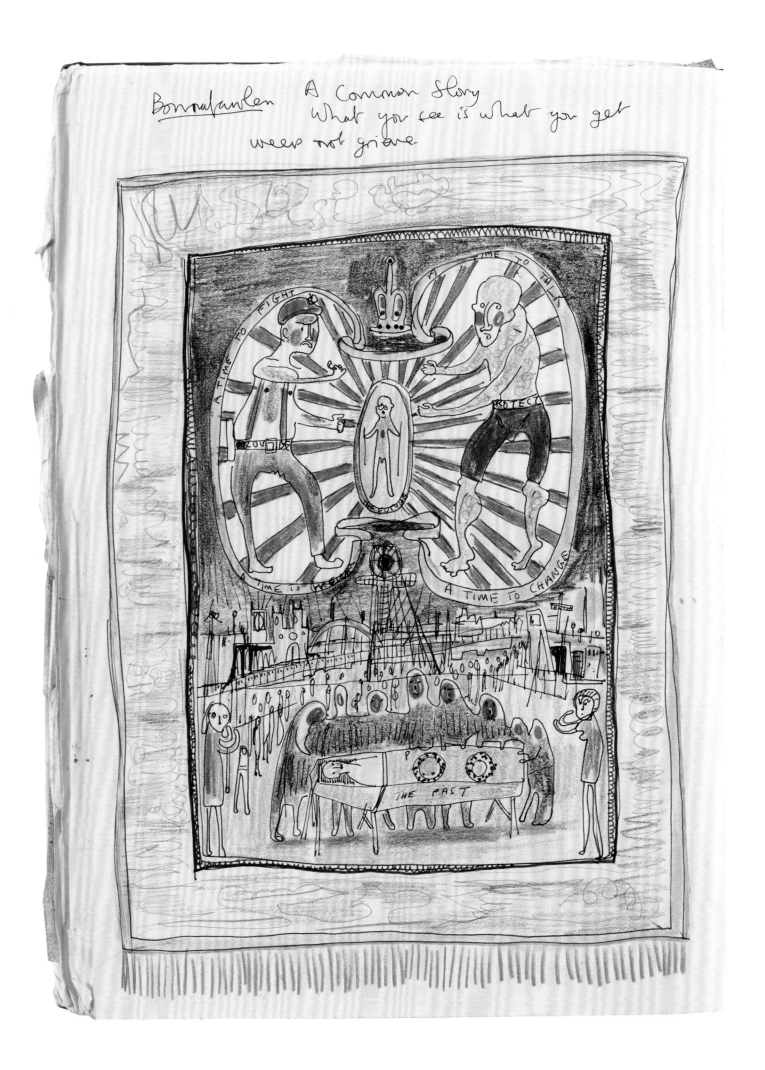

Death of a Working Hero — This is the final sketch
before I started the actual design. I wanted
an image that read well from a fair distance –
I imagined it as a kind of funeral parade banner.

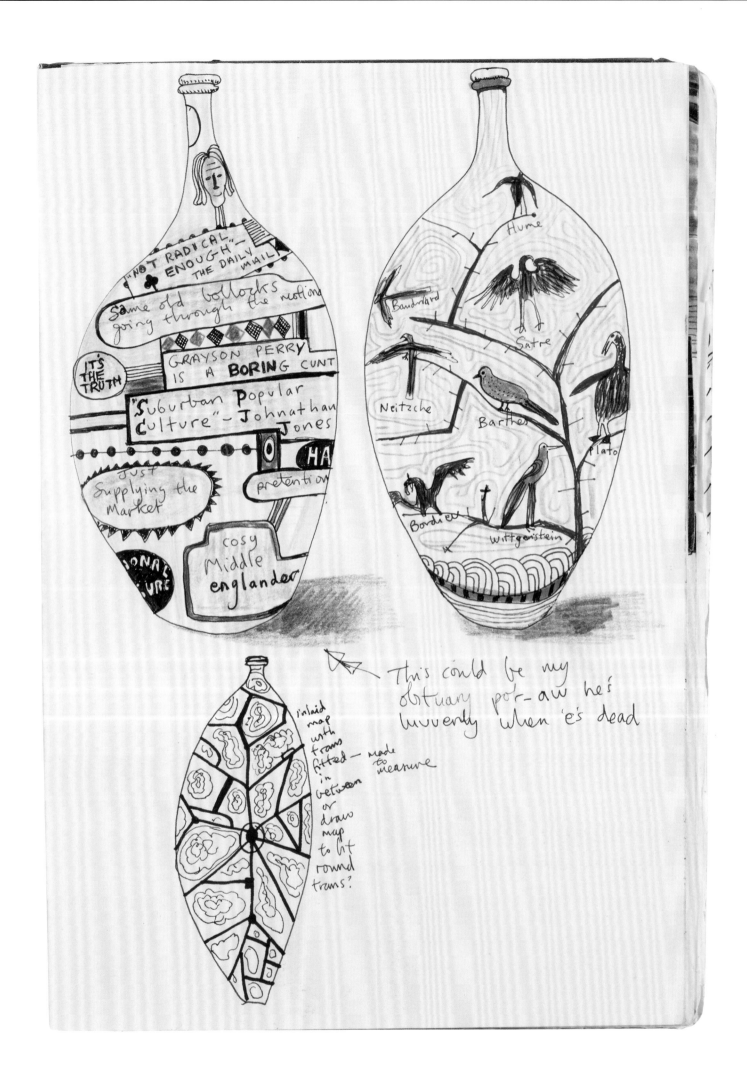

Puff Piece — Quite often a work springs out of
idly doodling with a sense of mischief.

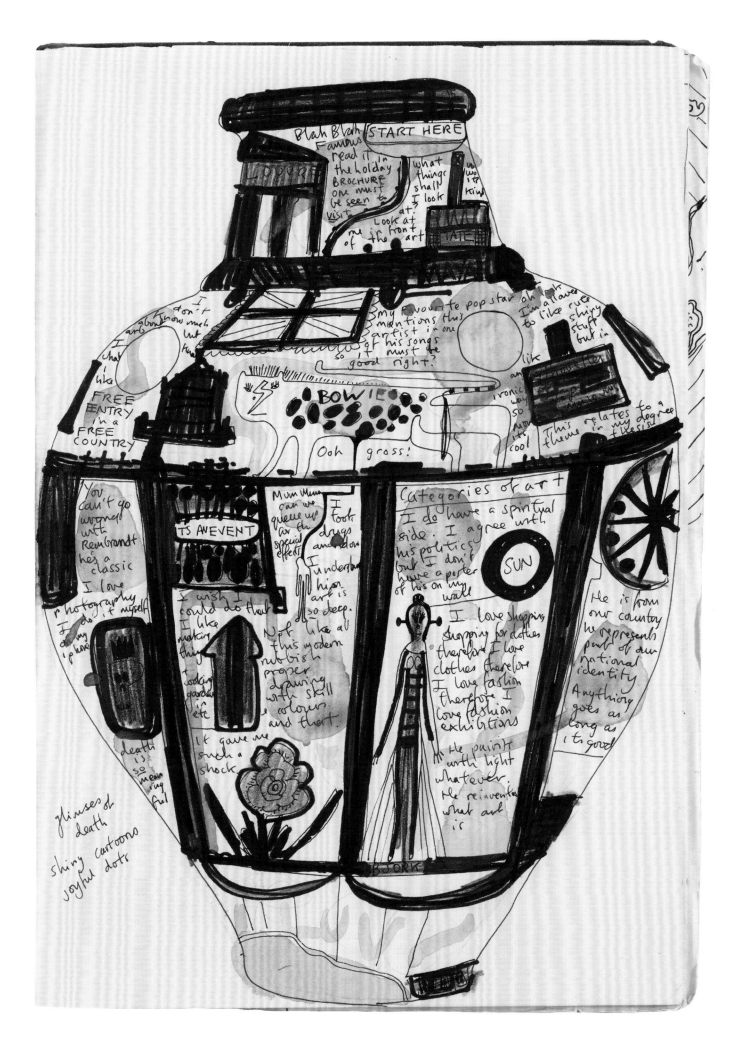

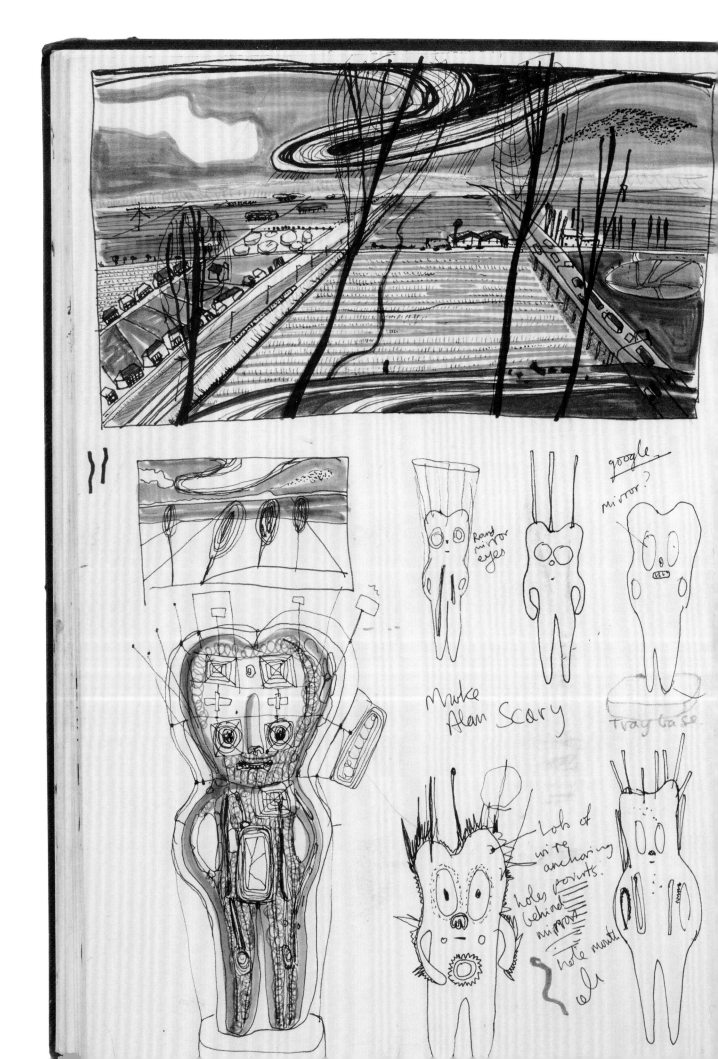

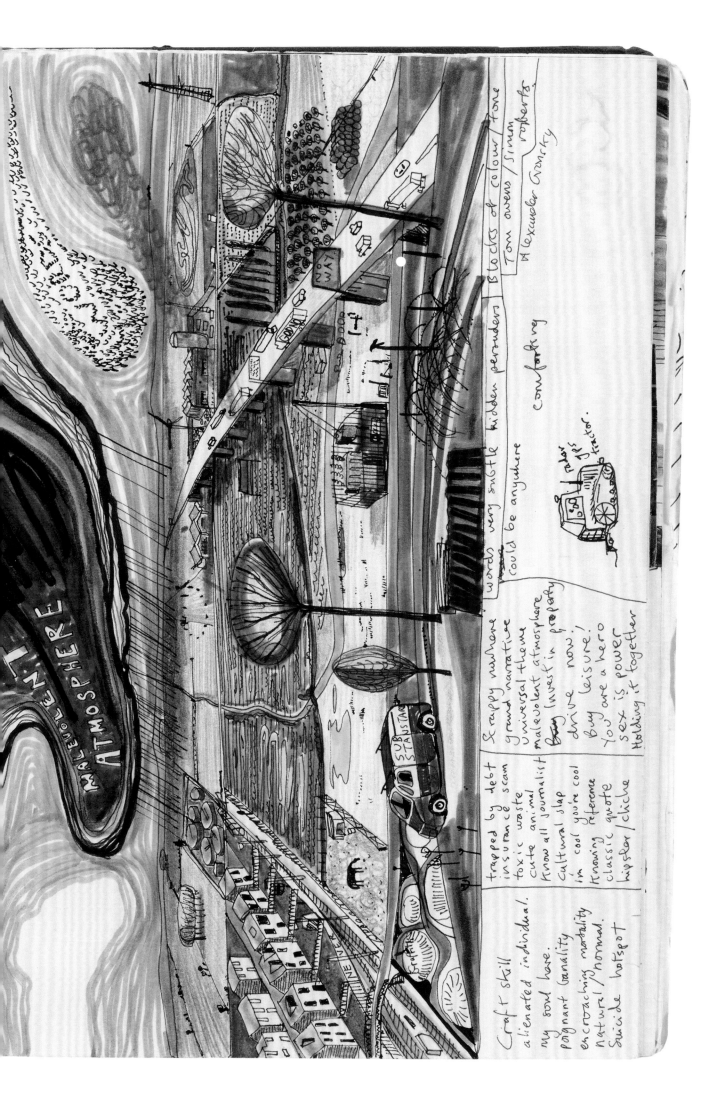

MALEVOLENT ATMOSPHERE

Craft skill
alienated individual.
my soul hare.
pognant banality
encroaching mentality
natural/normal.
Suicide hotspot

trapped by debt
insurance scam
toxic waste
cute animal
know all journalist
cultural slap
in cool you're cool
Knowing
classic quote
hipster/cliche

Scrappy nuance
grand narrative
universal theme
malevolent atmosphere
Buy Invest in property
drive now!
Buy leisure!
You are a hero
sex is power
Holding it together

words very subtle hidden perenders
could be anywhere comforting

Blocks of colour tone
Tom owens/Simon roberts
Alexander Gronsky

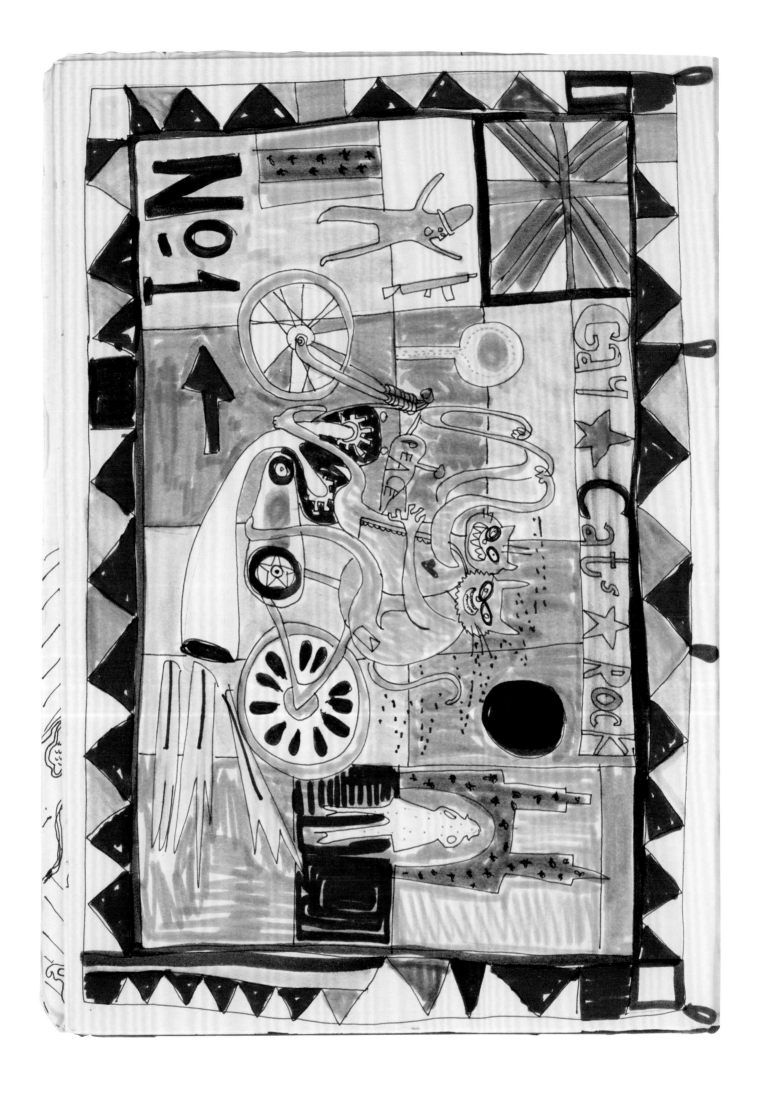

Gay Black Cats MC — Somewhere behind this piece is the feeling of nostalgia for a time when it was easier to be a shocking rebel.

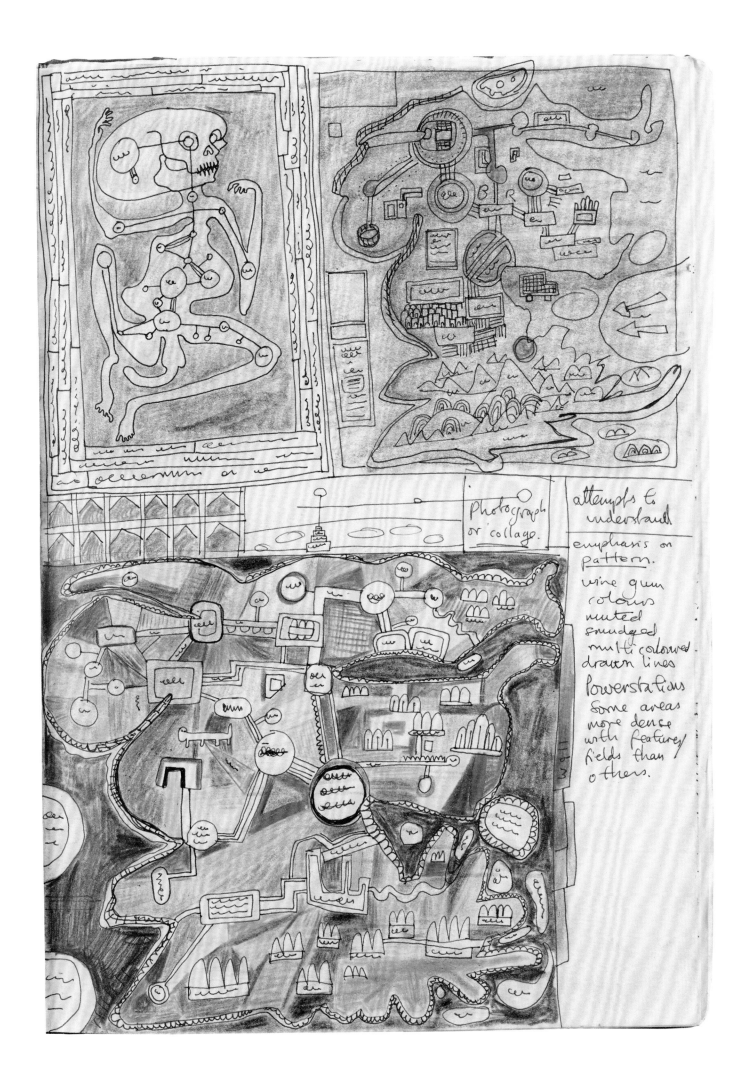

Photograph or collage.

attempts to understand emphasis on pattern. wine gum colours muted smudged multicoloured drawn lines powerstations some areas more dense with features fields than others.

Red Carpet — At first I wanted to show the map of Britain upside down as a metaphor for how the referendum had thrown the country into political turmoil.

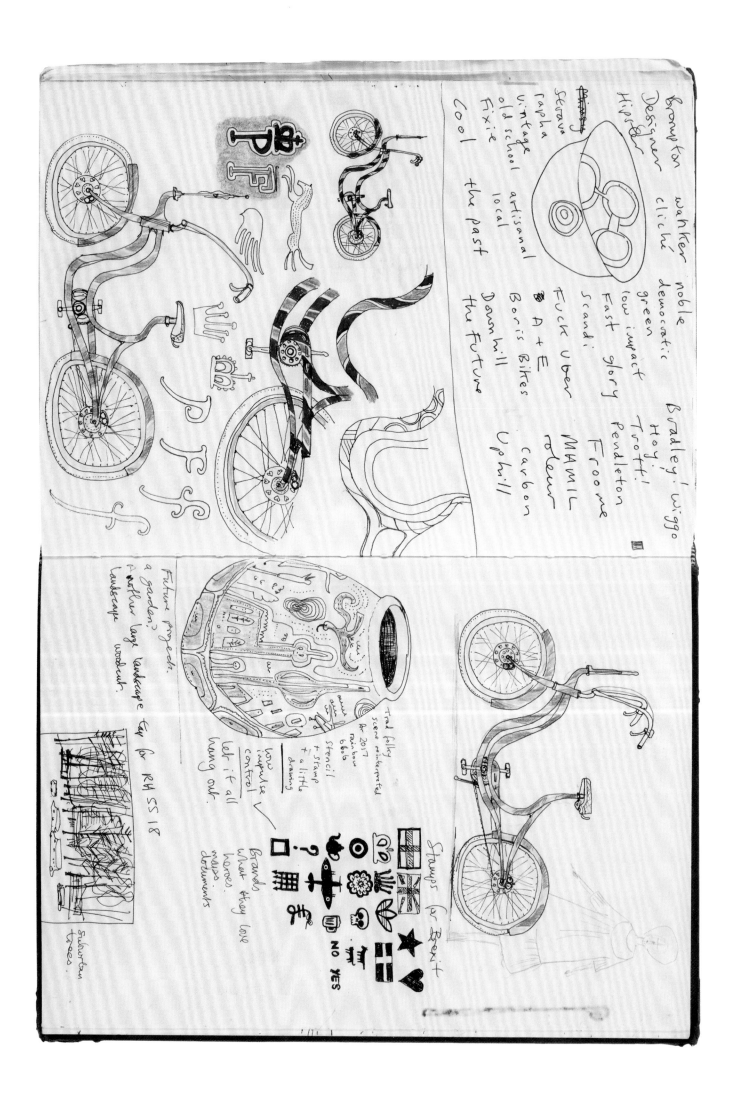

Princess Freedom Bicycle — Cycling has recently become hugely popular. Mirroring the interior of my mind, these pages also show jottings for four other projects.

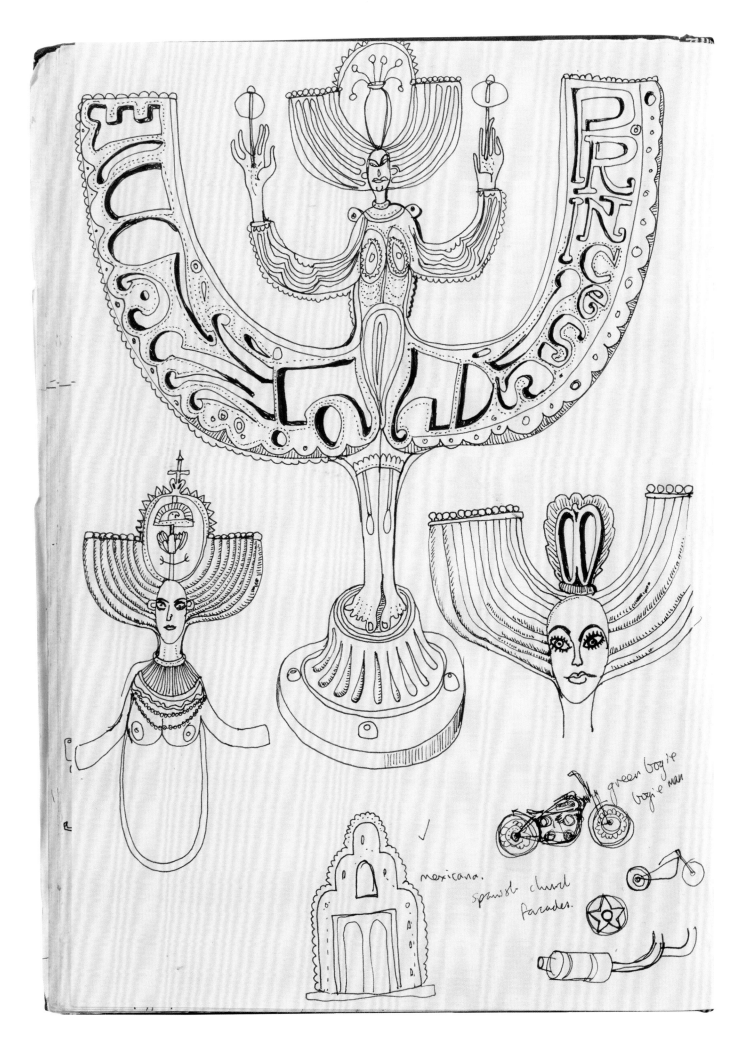

Princess Freedom — The shape of the sculpture
started as a hood ornament but one that could be
mimicked by the shape of some bicycle handlebars.
The fact it came out looking a bit like a Menora
was a coincidence, but I like the association.

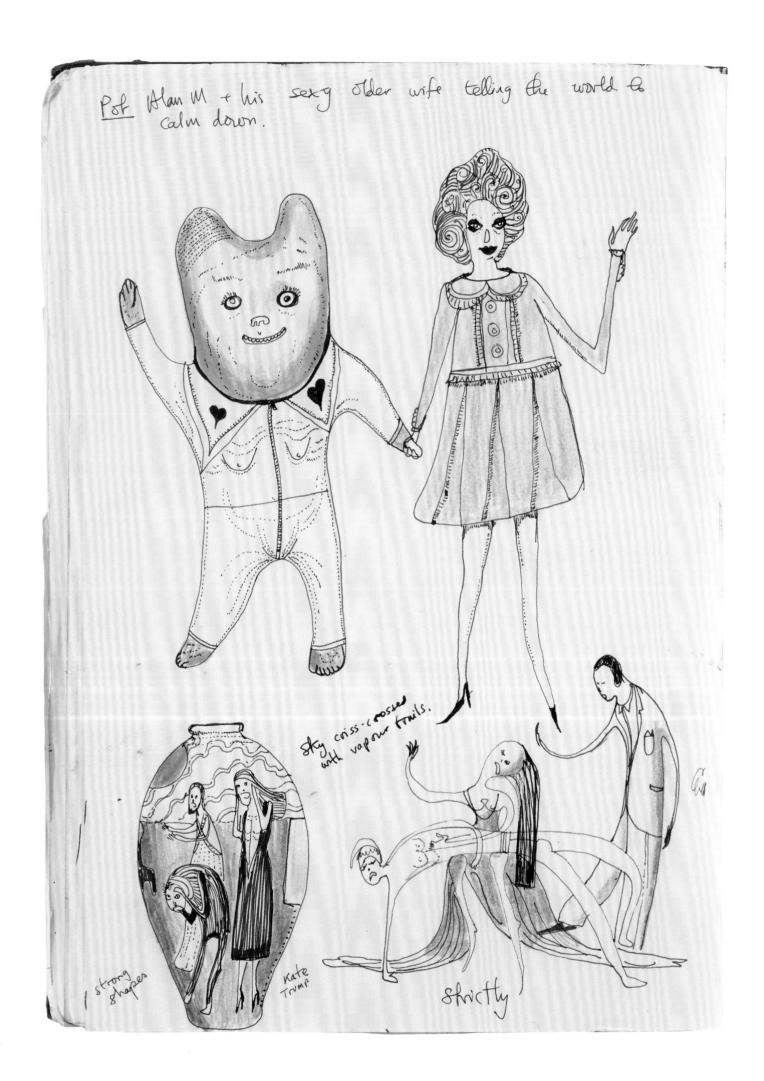

Alan Measles and Claire Visit the Rust Belt — From his experience as a leader and also a spiritual guru Alan often despairs at the behaviour of politicians. Such was the level of ridiculousness in 2016 that he felt the need to step in.

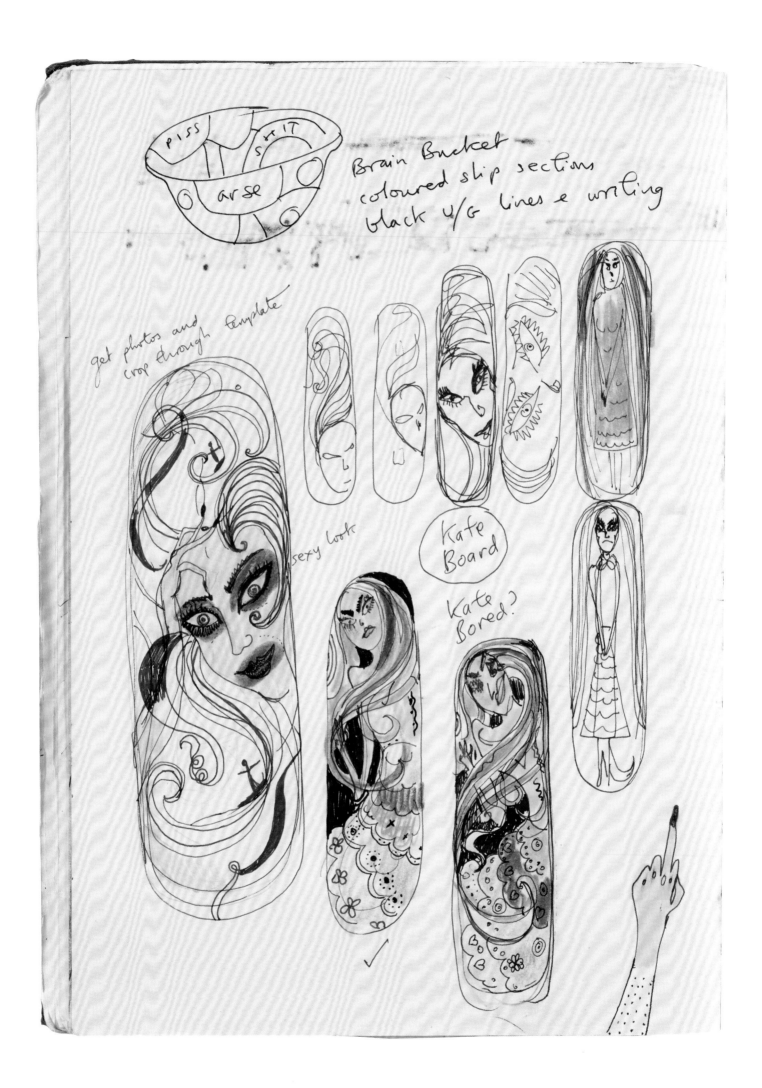

Kateboard — In my original sketches I wanted the Duchess
of Cambridge to have more of an angry rebellious image.

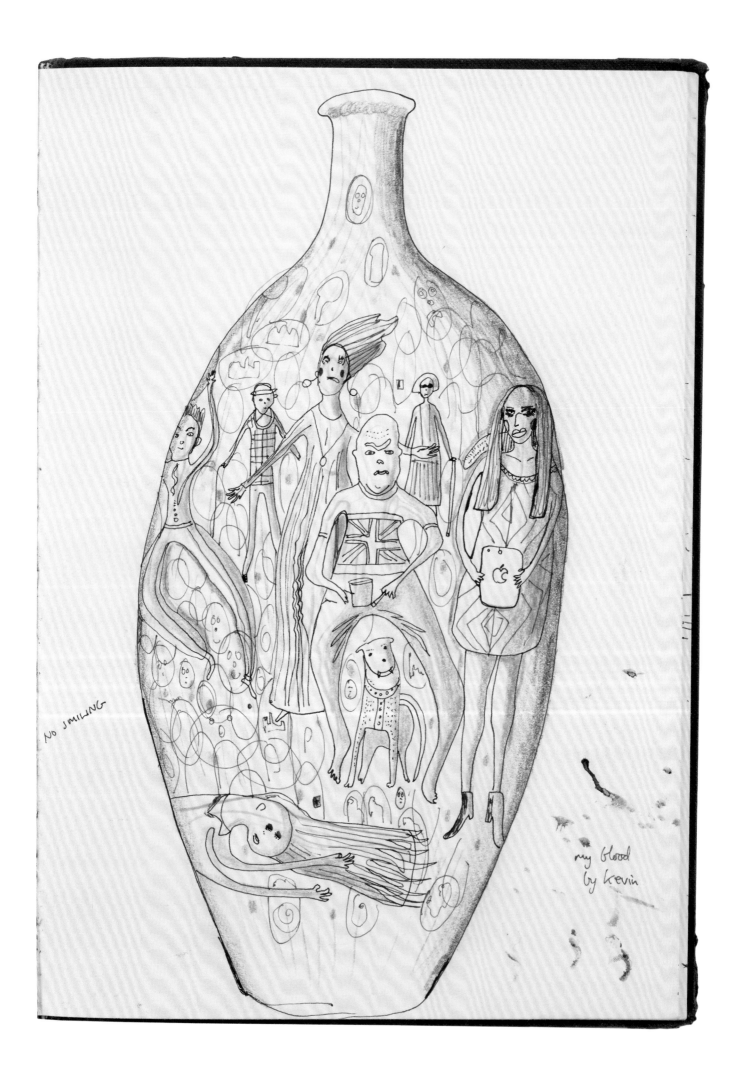

NO SMILING

my blood
by Kevin

Matching Pair — An early sketch –
sorry, but I am the artist and I decide
how the pots are going to look.

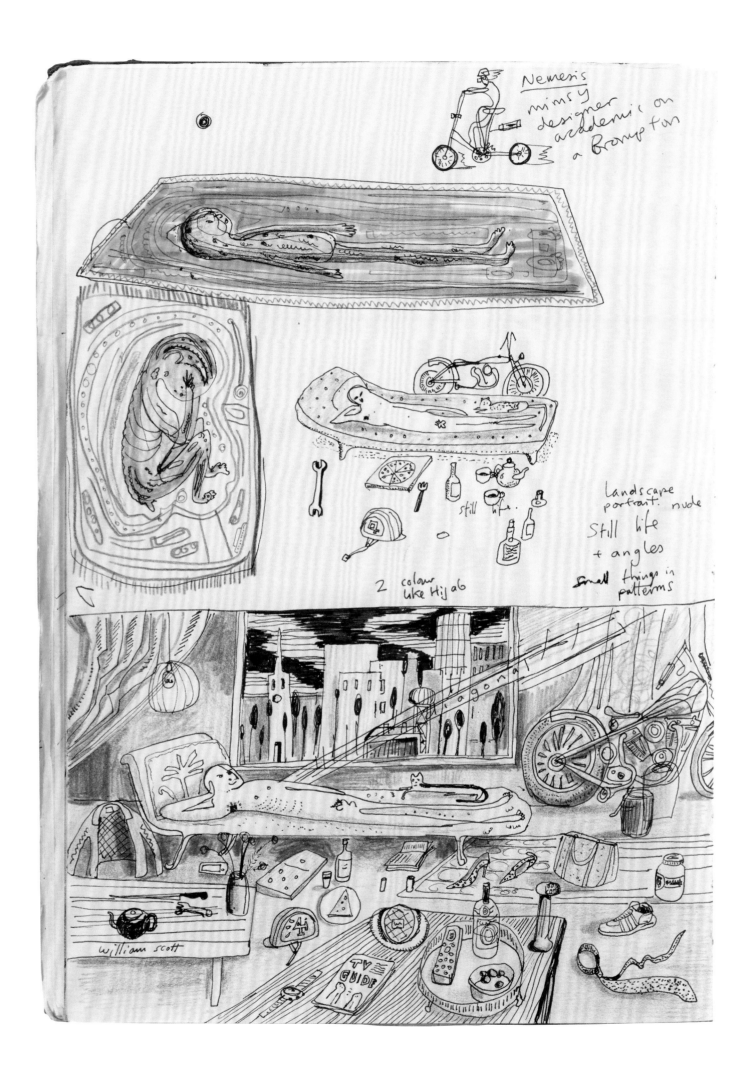

Reclining Artist — The initial spark for this large print
was an image of a man showing off his material
wealth and culture. No change there then.

Works

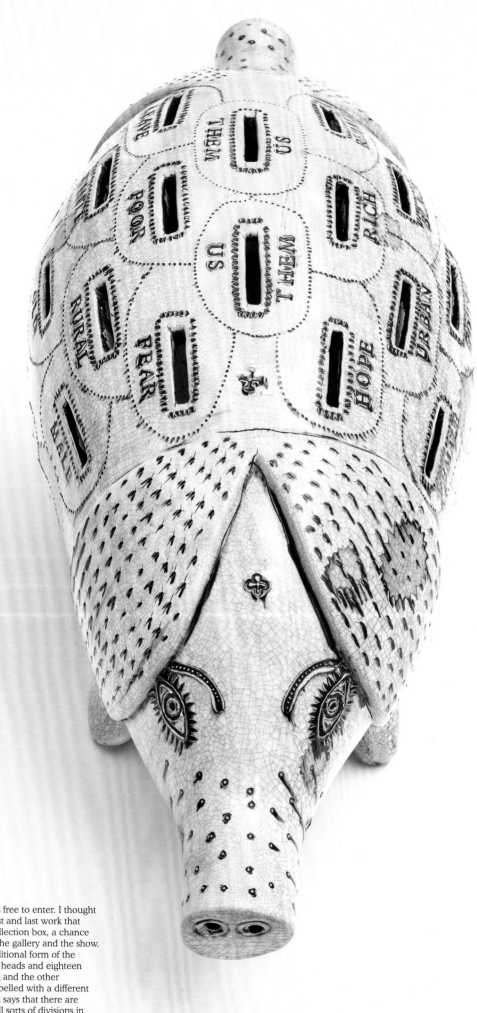

Long Pig

The Serpentine Gallery is free to enter. I thought it would be nice if the first and last work that visitors encounter is a collection box, a chance to show appreciation of the gallery and the show. I have made it in the traditional form of the piggy bank, but with two heads and eighteen slots. One head is smiling and the other grimacing. Each slot is labelled with a different type of person. This work says that there are winners and losers and all sorts of divisions in society, but we are all in this together.

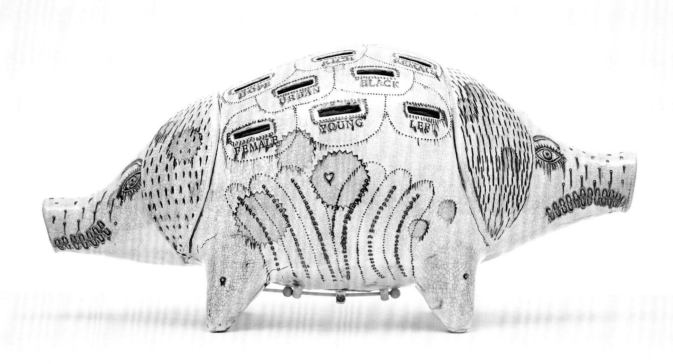

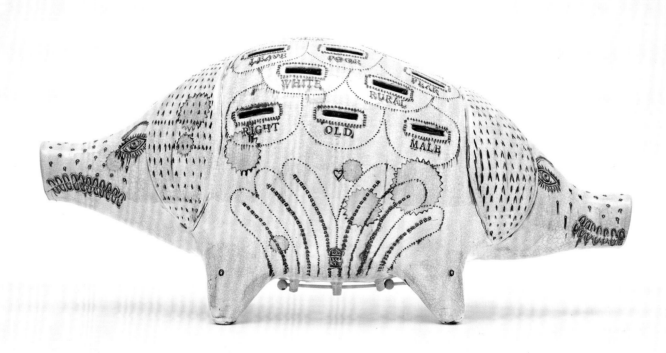

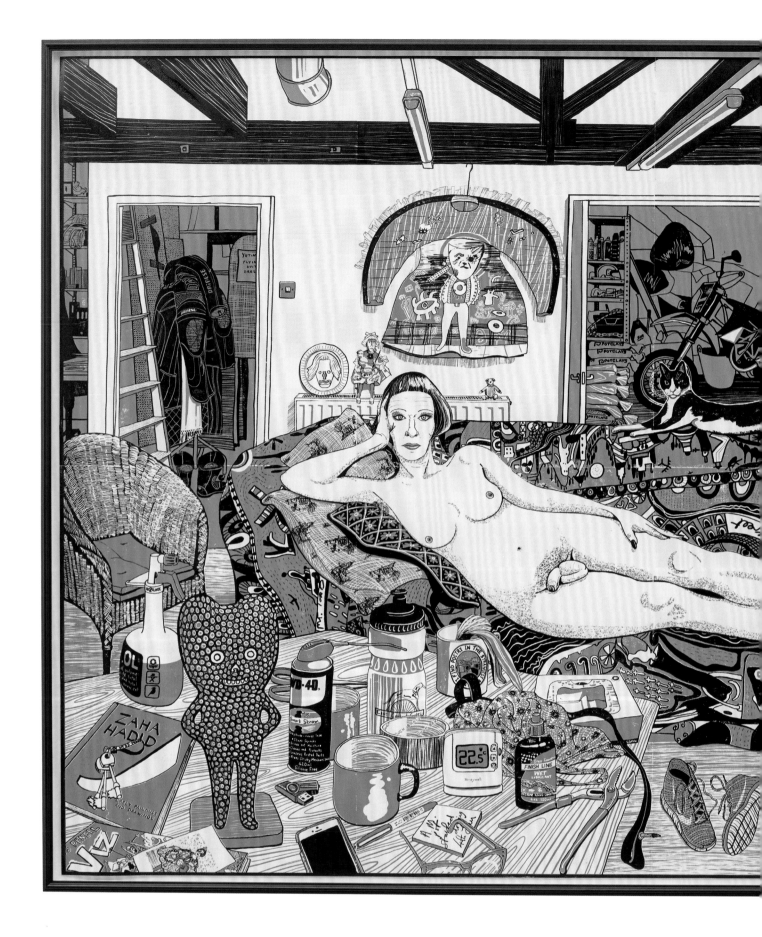

Reclining Artist

This is me, both as artist and model in my studio. I wanted to make
something in the tradition of the reclining nude. I'm hoping it will be
popular with educated middle-class people who might enjoy spotting
the art-historical references within it. *Reclining Artist* is both an idealized
fantasy and also the messy reality. It is perhaps me expressing my desire
to be a sex object and also show off my cultural capital and boyish
paraphernalia. The sofa is draped in a test piece for my 2011 tapestry
Map of Truths and Beliefs. Alan Measles, my teddy bear and metaphor
for masculinity and god, appears as a sculpture, as an inflatable and on
a dress hanging on the wall. The cat is called Kevin.

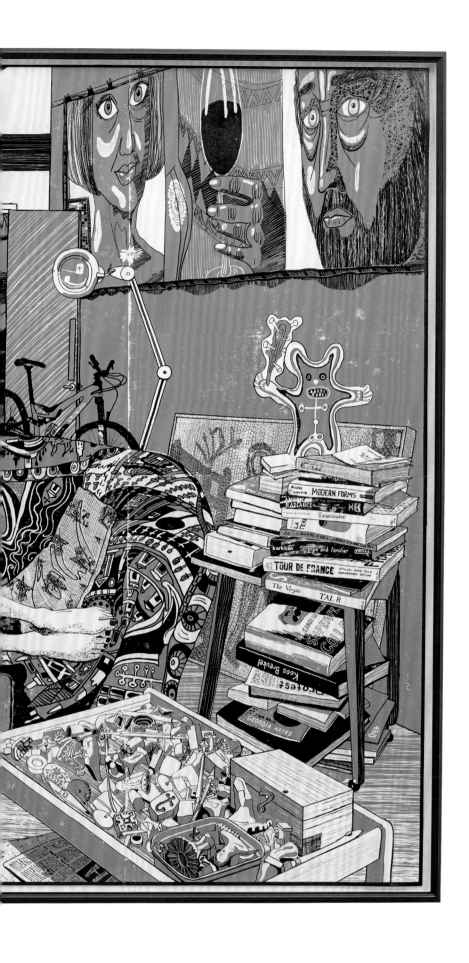

Alan Measles and Claire Visit the Rust Belt (overleaf)

This pot is a companion piece to a 2009 work called
*World Leaders Attend the Wedding of Alan Measles
and Claire*. That work showed Alan and Claire in
carnivalesque folk costume; in this work Alan wears
an astronaut's suit and Claire is dressed as a 1960s
astronaut's wife. President Trump kisses Alan's hand as
Melania Trump, Nigel Farage and Marine Le Pen look
on. Claire's hand is held by Jeremy Corbyn, whilst Boris
Johnson and Theresa May observe. Alan is a traditional
hero brought back from retirement to sort out the mess.

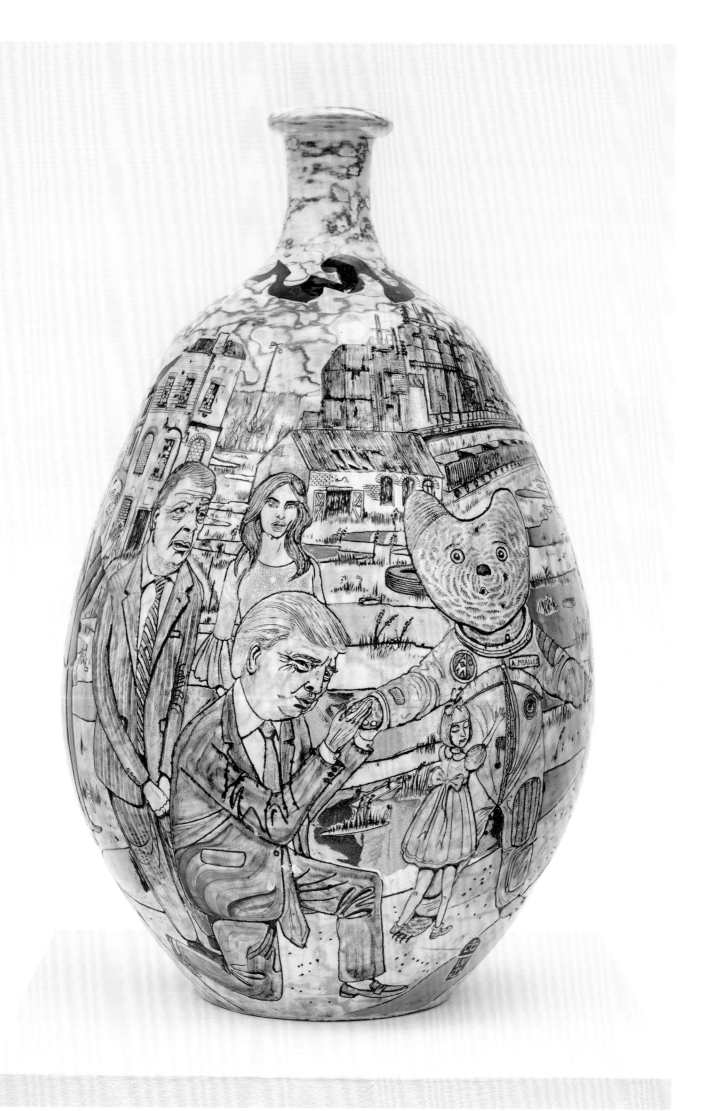

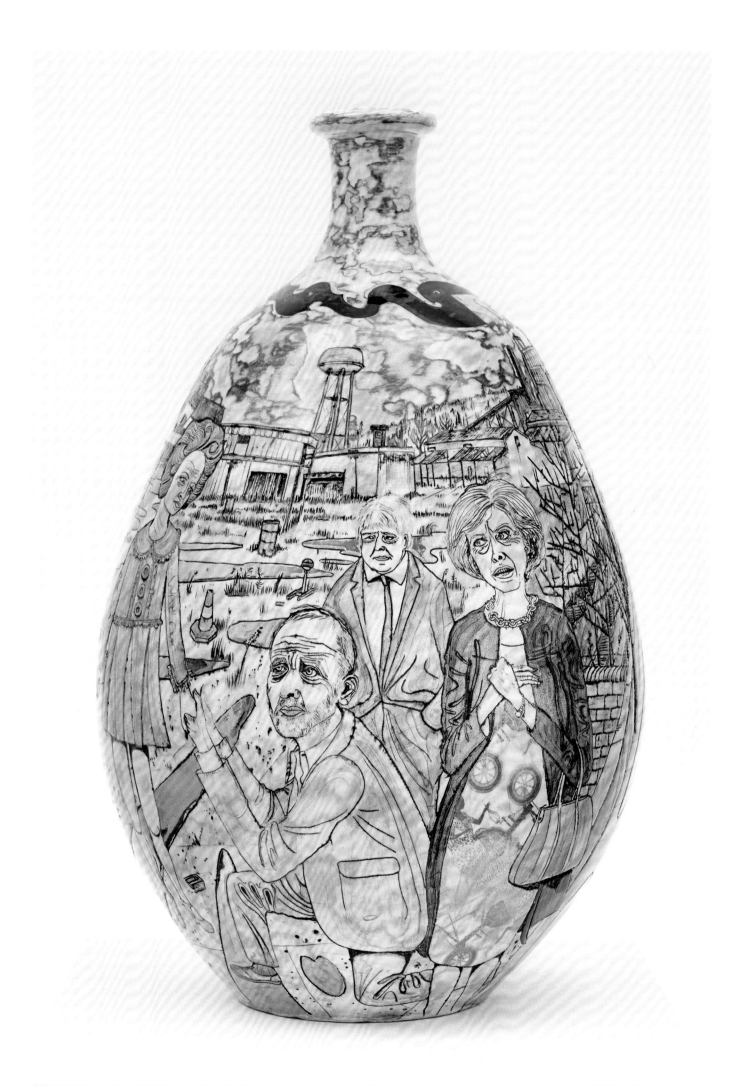

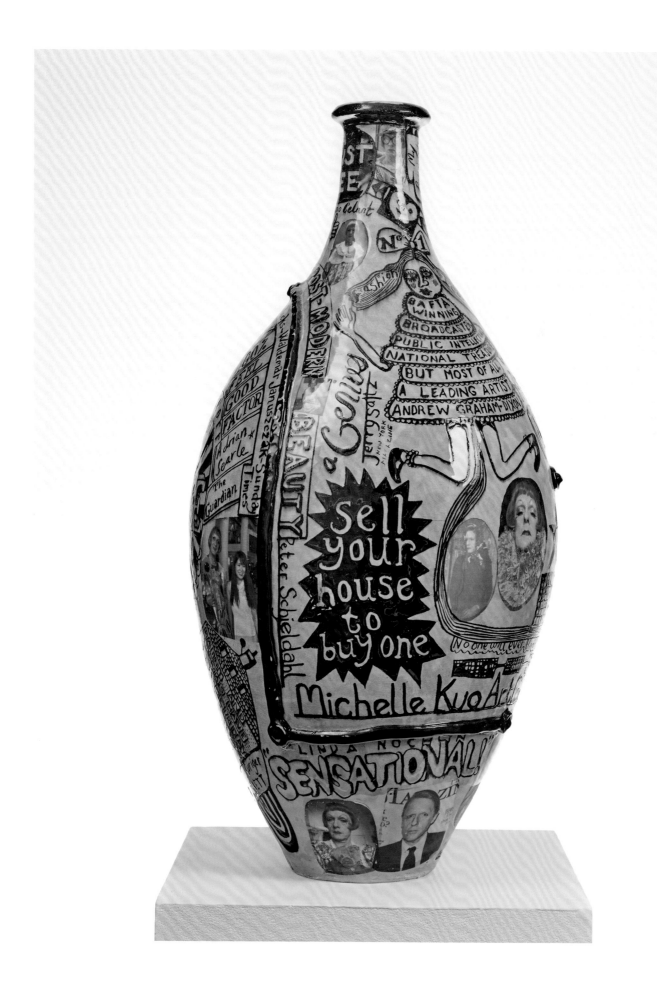

Puff Piece

This work is like those boards they hang outside theatres featuring choice quotes about the show from critics. I have made up these quotes about me and put them next to the names of famous and influential art critics. I cannot bear to read reviews of my work these days. The good ones affect me just as much as the bad ones and I can quote negative reviews decades old from memory. Though they may not like it, PR is now a necessary part of any artist's career.

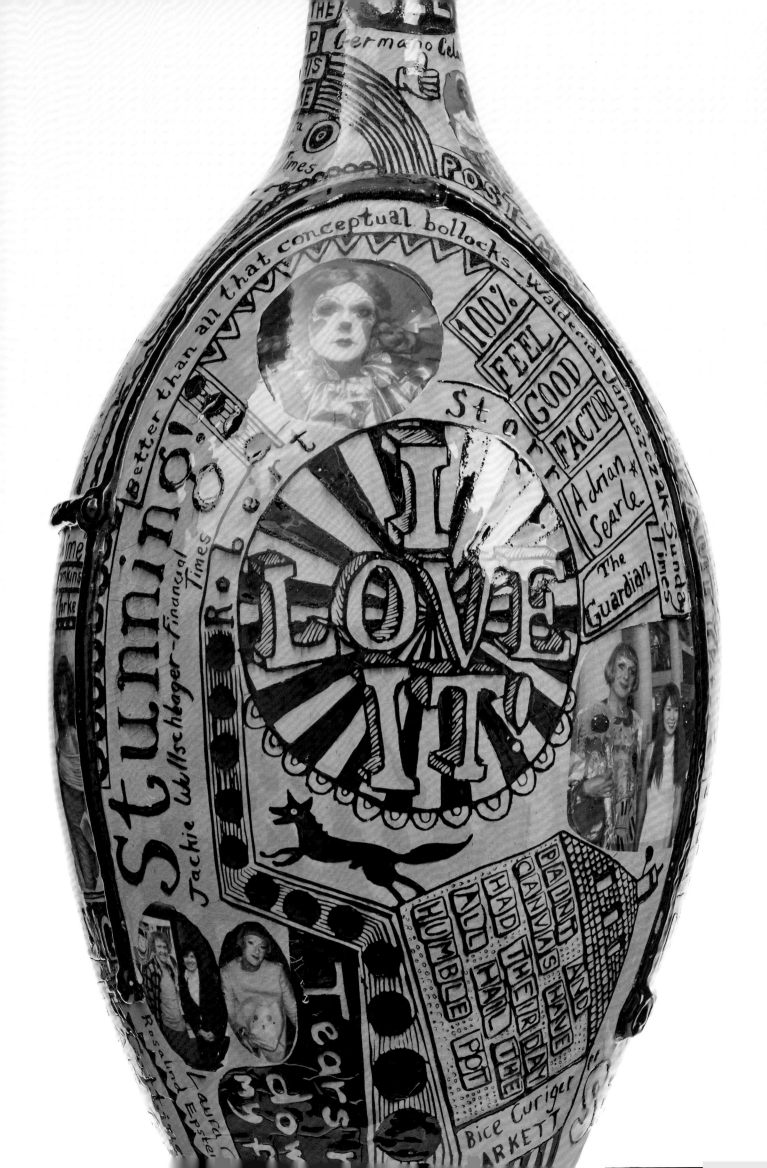

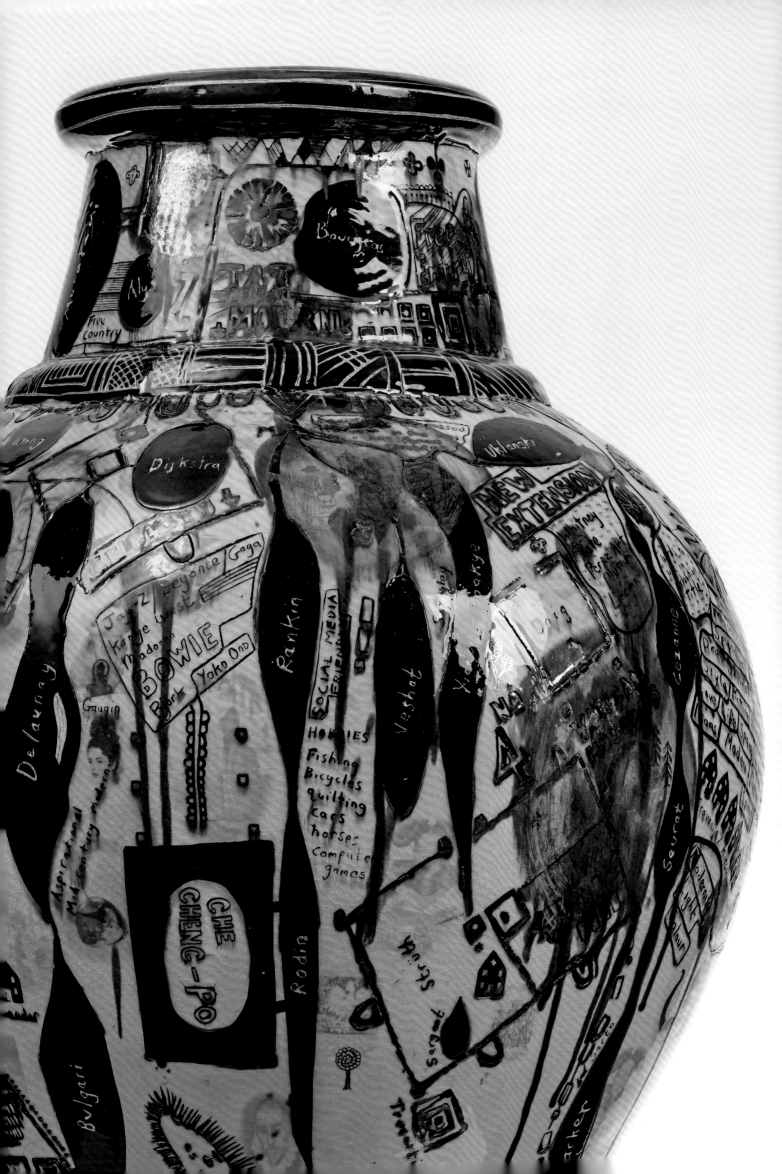

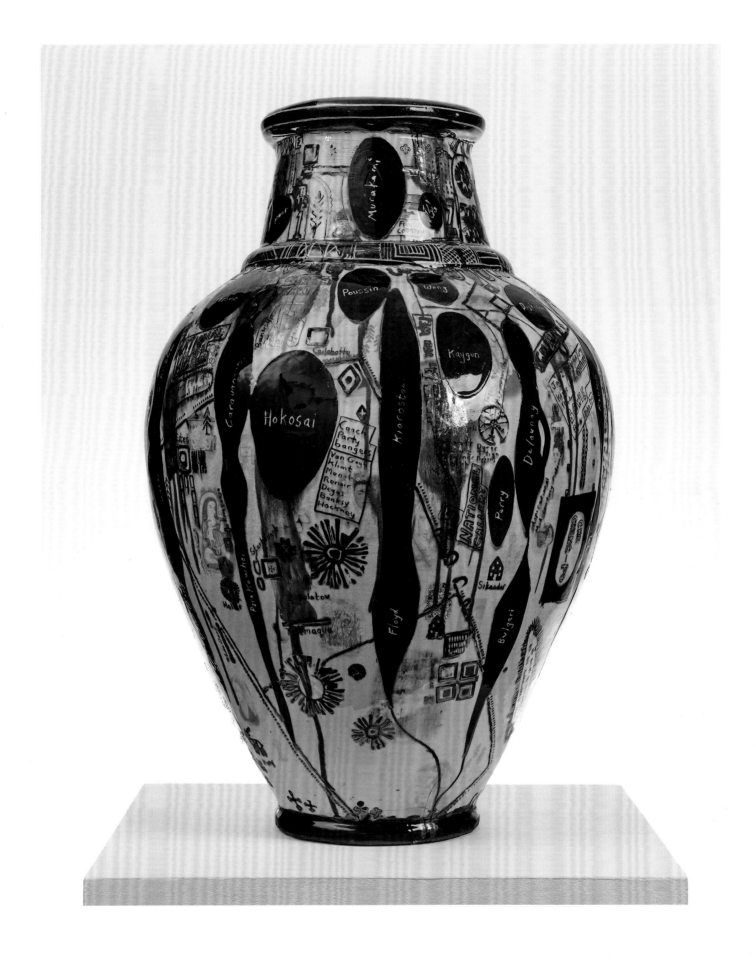

Visitor Figures

The decoration of this pot is loosely based on *The Art Newspaper* visitor figures supplement. The surface of this vase is a map of names, images and places who feature on the most popular exhibition lists. I have executed the decoration in quite a painterly organic style, maybe as a counterpoint to the cold hard statistics of who and what is the most popular. Artists often have a conflicted relationship with popularity. I have heard artists who make 'difficult' work and who refuse to do PR complaining that they get little attention.

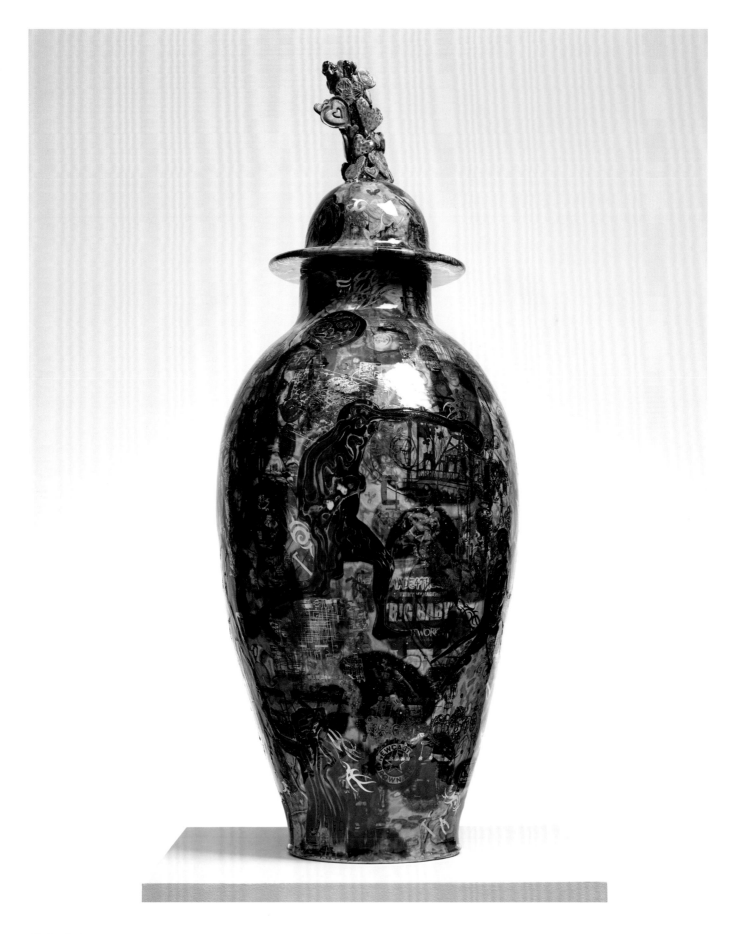

Shadow Boxing

The collapse of heavy industry that formed the communal identity
of many parts of northern Britain was a shock that still reverberates
decades later. For many males in these areas unemployment and
changing work cultures also undermined the foundations of what it
was to be a man. In the north east the macho stoic stereotype still
persists in a laddish drinking culture, but this peer pressure and
emotional repression can have a tragic cost. *Shadow Boxing* is a
memorial to the victims of that manly straitjacket, the men who
could not talk about their feelings, who could not cope, and who
took their own lives. The vase is topped by a heart-festooned shrine
that is inspired by a similarly festooned tree next to the grave of a
young man called Daniel. He also features on the vase in a
photograph of a tattoo portrait of him on a friend's leg.

The following six works were made as part of *All Man*,
my 2016 Channel 4 TV series investigating masculinity.

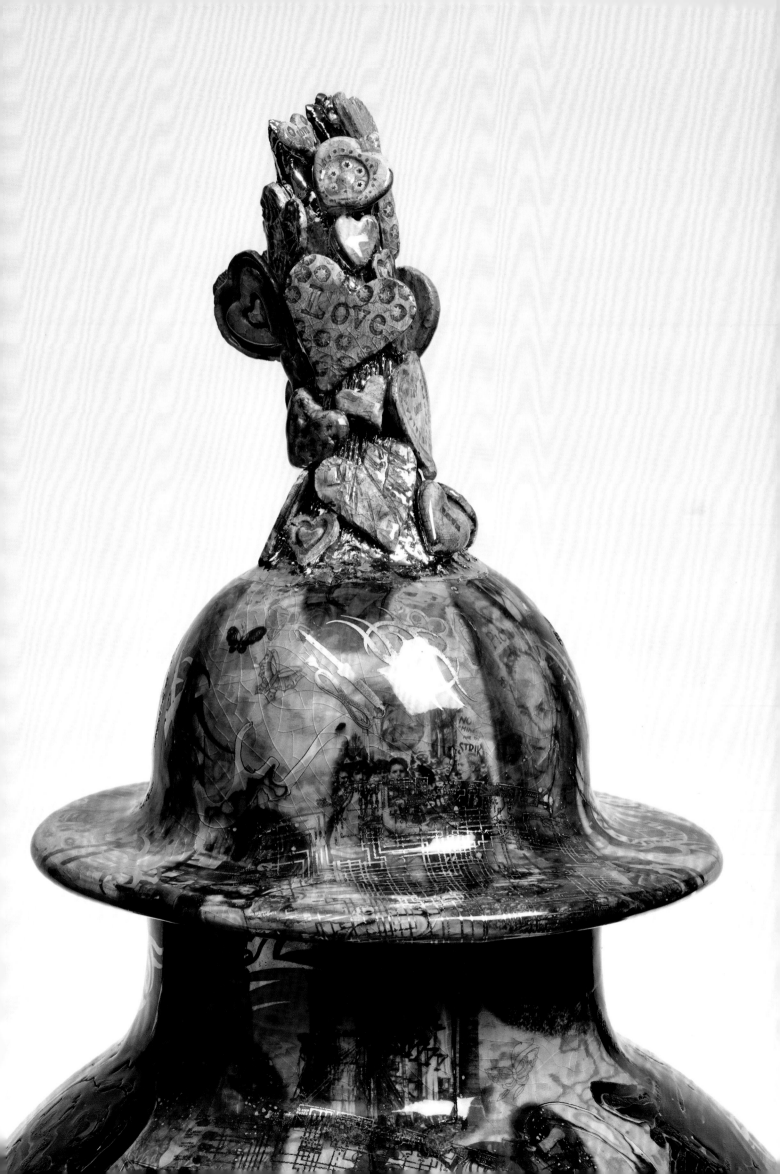

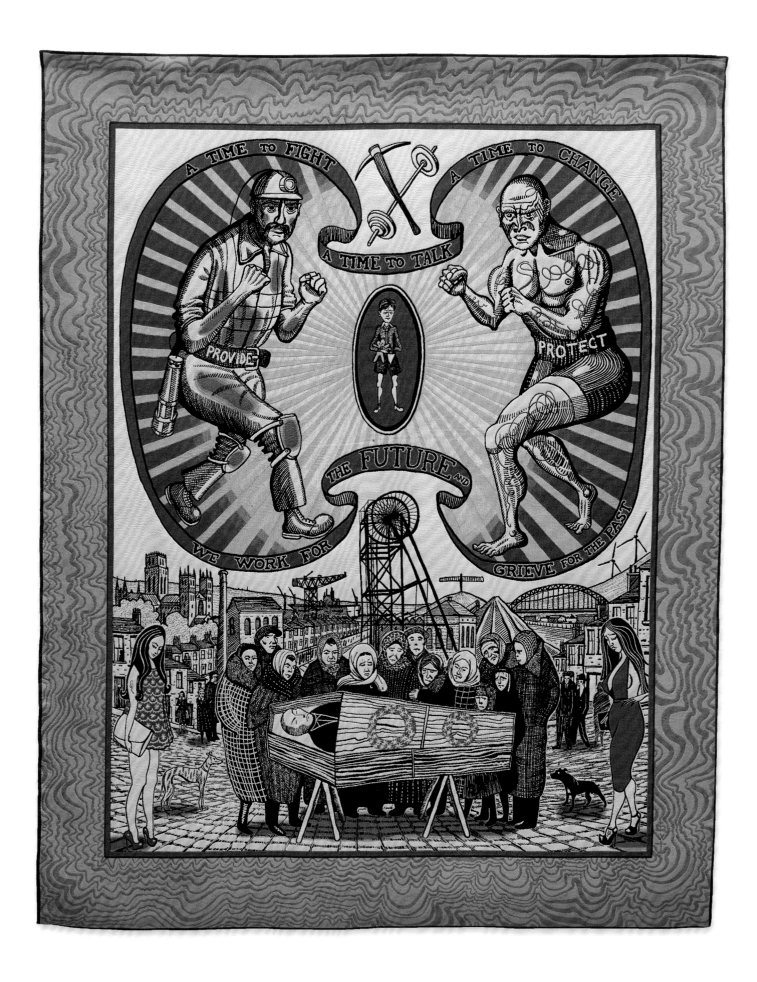

Death of a Working Hero

Death of a Working Hero was inspired by the ceremony of the blessing of the banners in Durham Cathedral. This moving ritual is part of the annual Durham Miners' Gala where trade-union banners are paraded through the streets accompanied by brass bands. The blessing in the glorious setting of the cathedral accompanied by mournful music seemed to me to be a funeral for a certain sort of man.

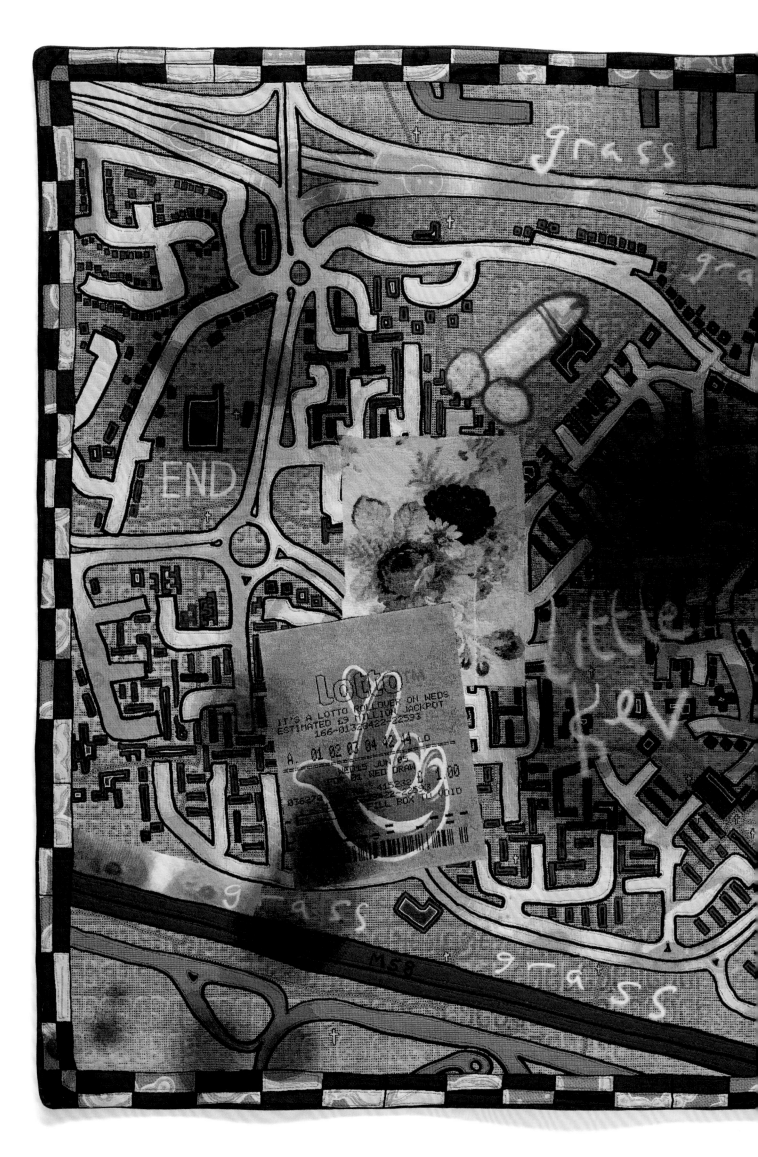

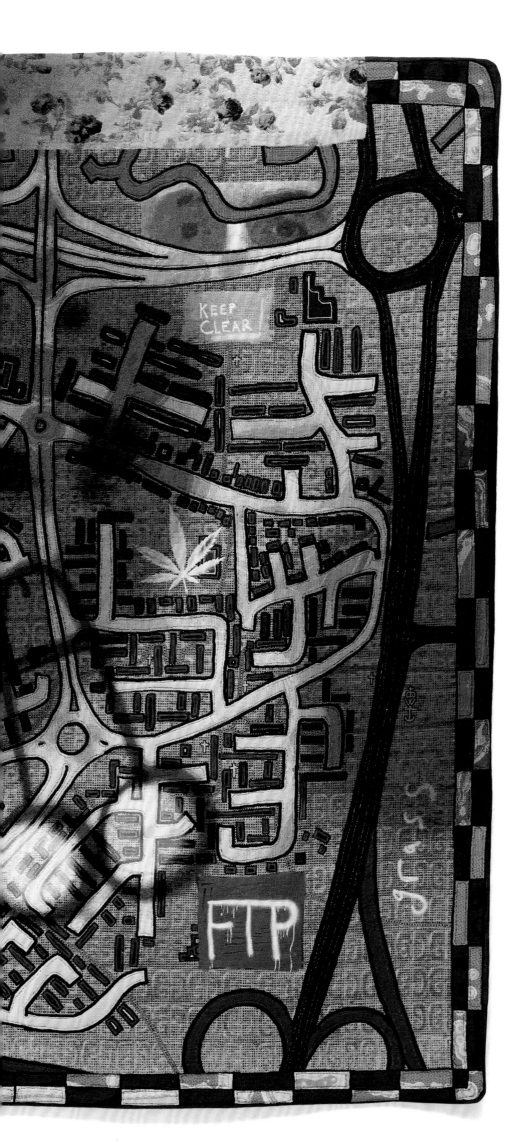

The Digmoor Tapestry (left)
and *King of Nowhere* (overleaf)

This pair of works are my reaction after talking to a group of young men from Skelmersdale, Lancashire. They are the victims of poverty, chaotic parenting, bad role models and disrupted education. They hung around street corners selling weed, riding motorbikes around parks and getting into fights with rival groups. They were at an age when a hormonal need to assert their masculinity was at its freshest. Deprived of acceptable badges of status, job, money, education, power and family, they exercised their masculinity in a way that seemed to echo back to the dawn of humanity – they defended territory. That territory was the Digmoor estate, a quadrant of a 1970s new town bounded by dual carriageways. They seemed prepared to kill for it. *The Digmoor Tapestry* is a map of the estate they defended. The style was inspired by traditional African fabrics and the graffiti is taken directly from the boys' environment. On seeing it one of them commented, 'It looks like it's been used to wrap up a body'. The *King of Nowhere* resembles an African power figure, but it is made of cast iron – the material used for bollards, those pieces of street furniture placed to deny access.

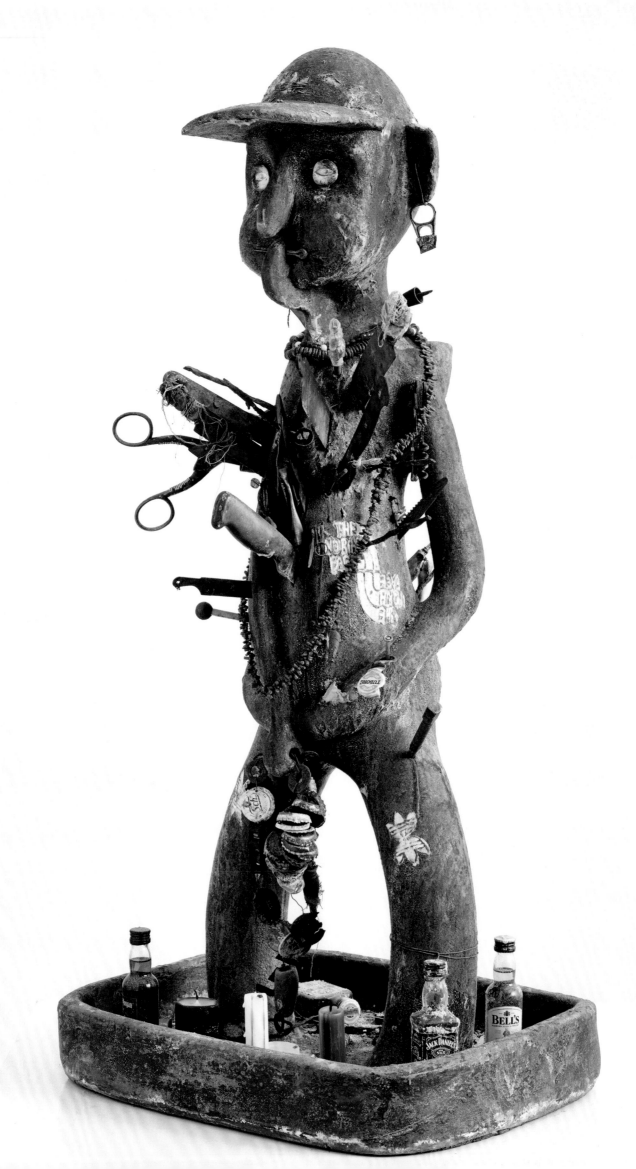

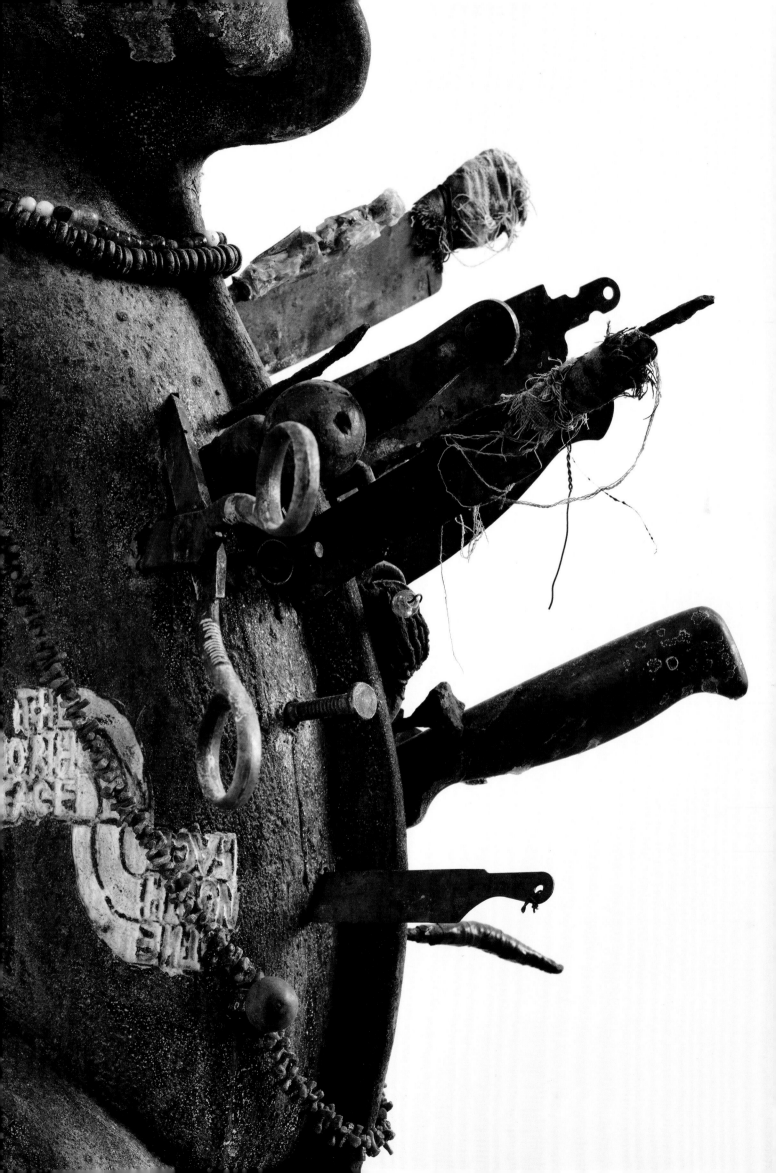

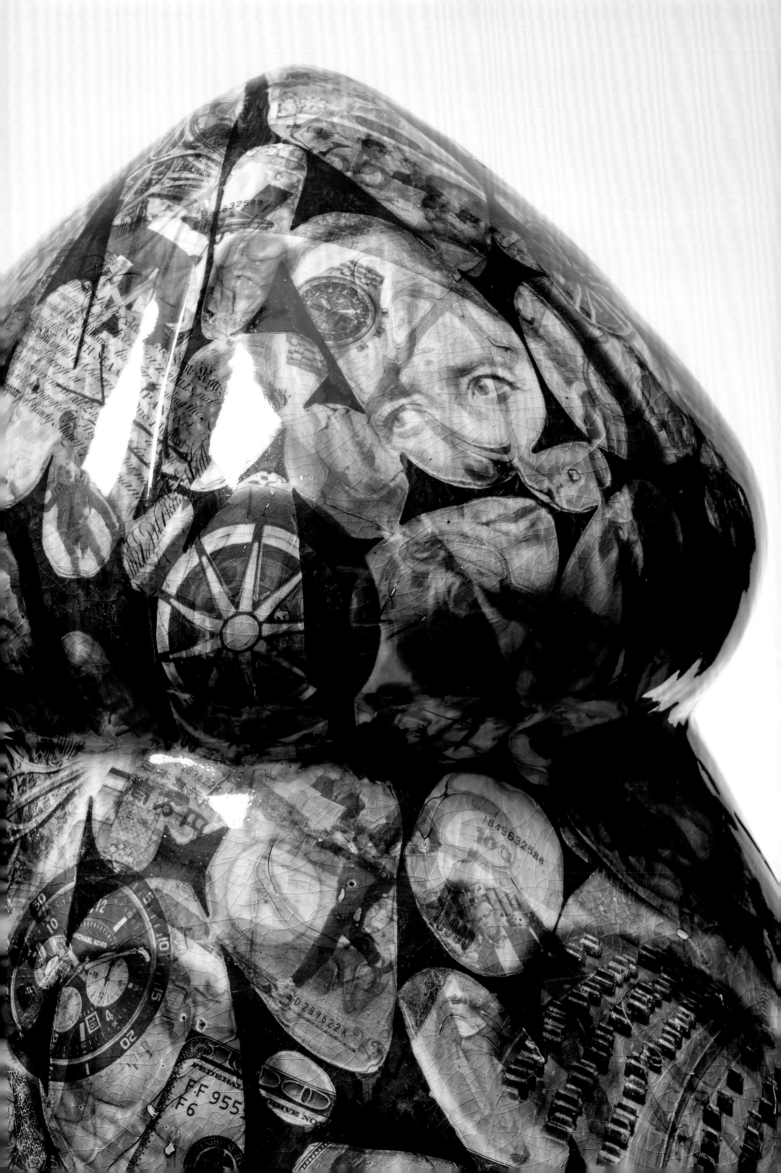

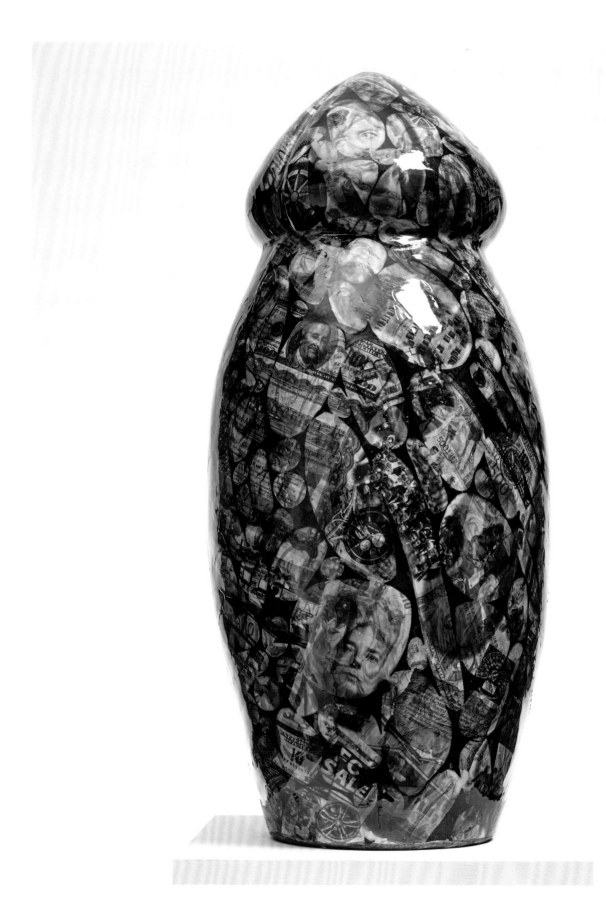

Object in Foreground

Perhaps the most difficult aspect of masculinity to examine
was its pervasive effect on the power structures and
unconscious bias within the City of London financial
industry. Men working there are well-educated, confident,
and operate in a culture of their own making, so it was
difficult to pick out the dominant threads of masculinity
from the dense and perfect weave of their business.
Object in Foreground was inspired by the bland lobbies
of their corporate towers. The décor expresses imperial
neutrality, but I saw them as bachelor pads writ large.
The masculinity of the city architecture was staring them
in the face, but it felt naively obvious to mention it.

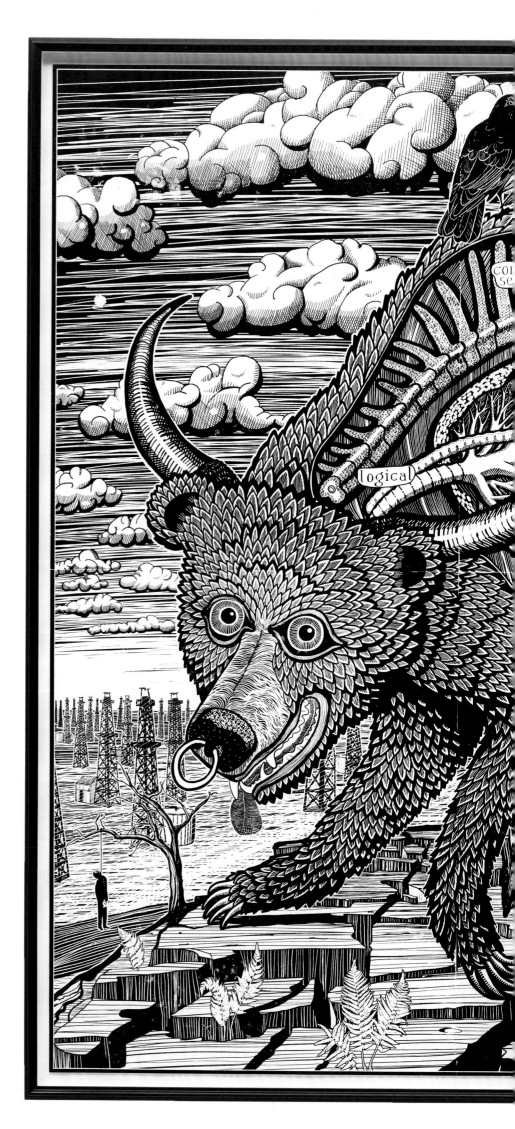

Animal Spirit

'Animal Spirits' was a phrase that cropped up quite a lot during the commentaries after the financial crash of 2008. It seemed to be used as a way of offloading responsibility for the human chaos of the meltdown onto some mystical force, when in fact the men controlling the market are as prone to irrational behaviour as anyone. Some of the symbolism within the image of *Animal Spirit* – the abandoned baby, the three black crows and the hanging man – come from the names of the traditional patterns in Japanese candlestick graphs used by traders in the City.

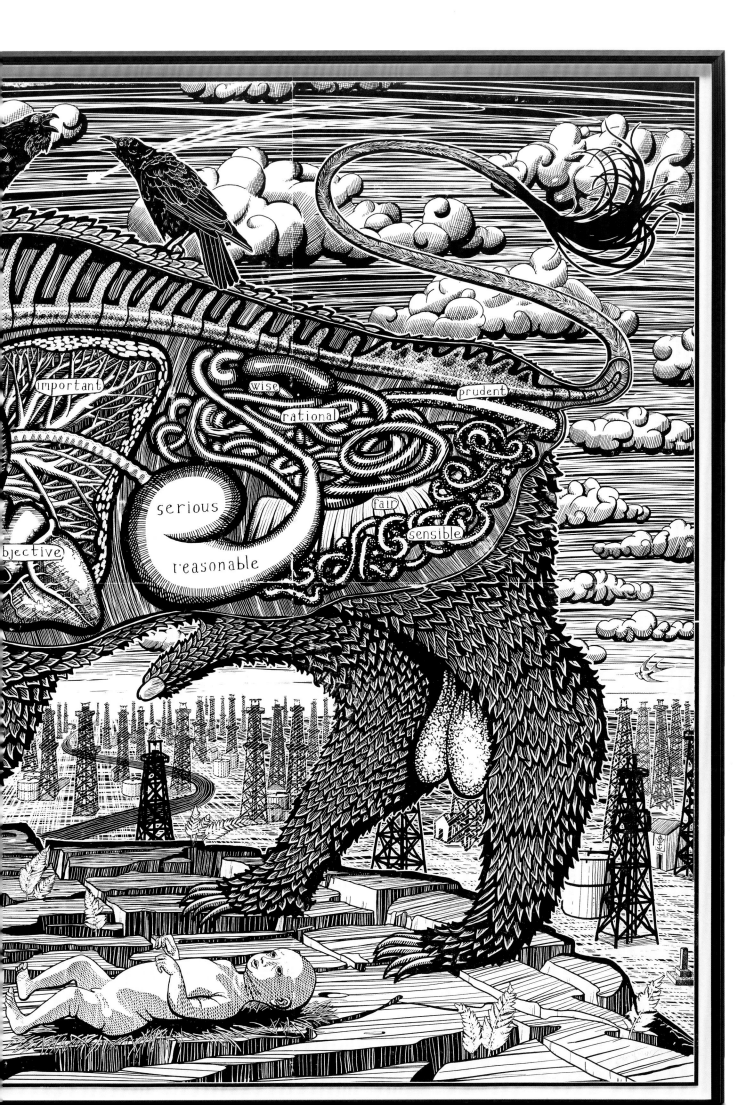

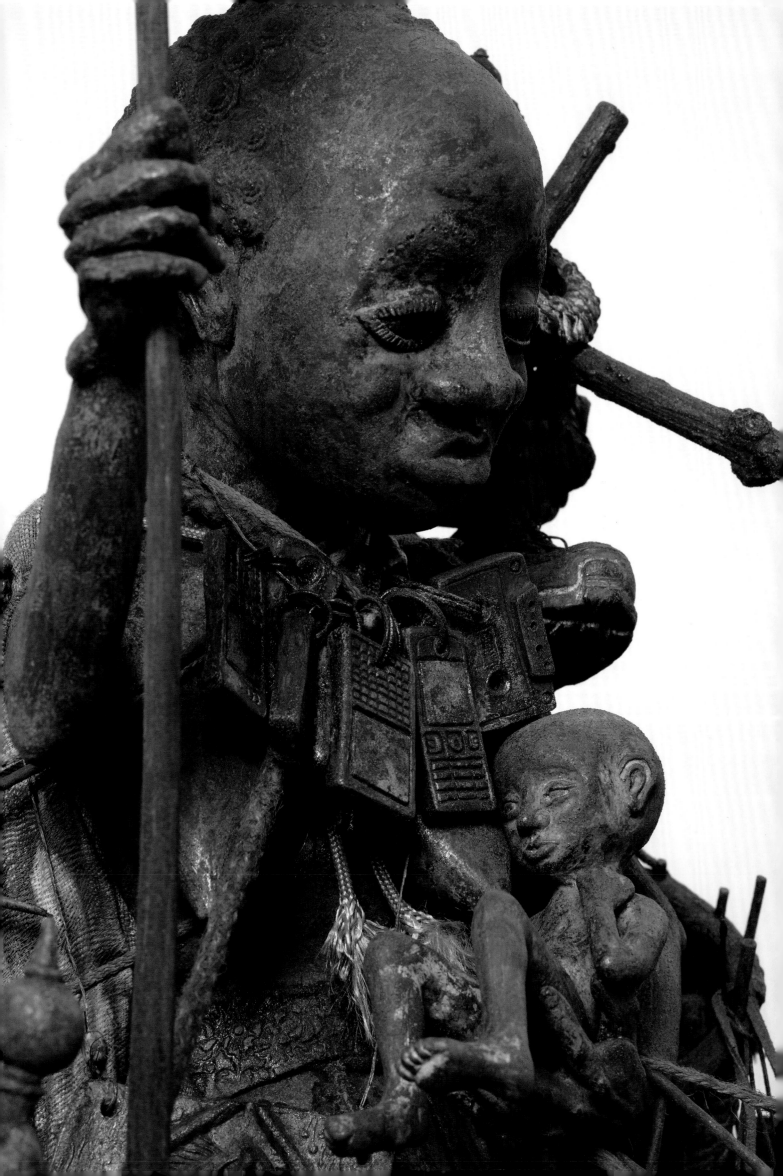

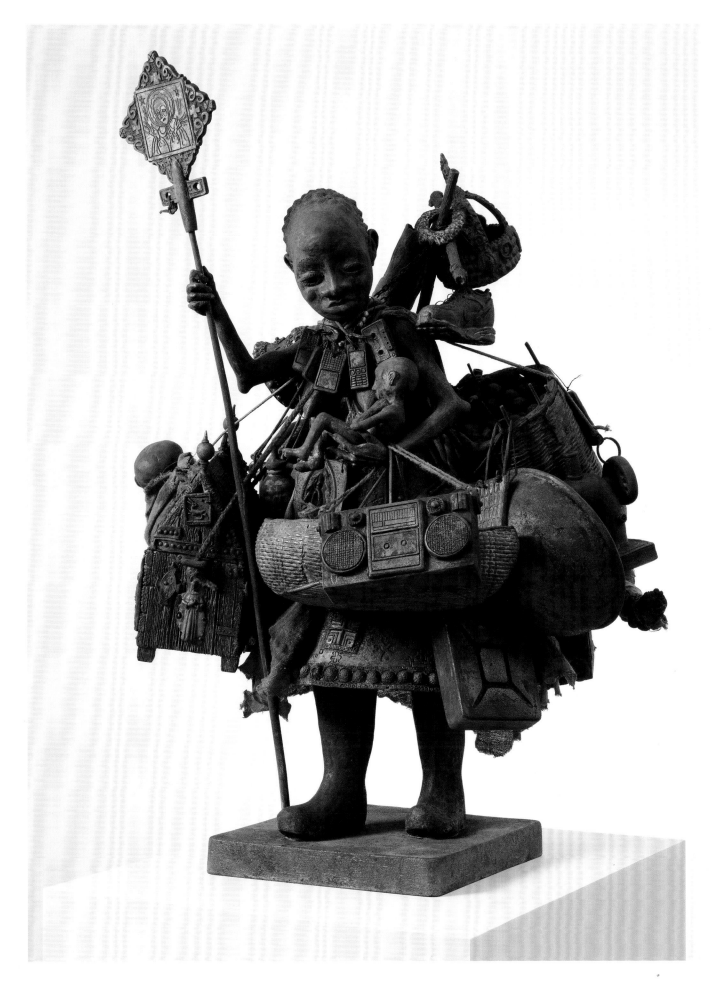

Our Mother

Originally made for my 2011 exhibition *The Tomb of the Unknown Craftsman* at the British Museum, *Our Mother* is all of us on our journey through life. She is a universal pilgrim seeking meaning, but more relevant to this exhibition is that she is also a universal refugee. Immigration was a central and very emotive issue during the EU referendum. I wanted *Our Mother* to be part of the conversation of works that deal with the biggest UK political event of 2016. She carries a great load of religious, cultural, domestic and parental baggage. She is also one of the most popular works I have made.

Red Carpet (right)

The title evokes the most formal and reverent of welcomes and the style is influenced by some of my favourite material culture – Afghan war rugs. This is a map of British society as evocative and inaccurate as a geographical one made by a medieval scholar. The distortions partly reflect the density of population rather than the lie of the land. It is covered in words and buzz phrases that I felt typified the national discourse in 2016. The background weave is made from photographs of tower blocks.

Battle of Britain (overleaf)

I started this work with the innocuous desire to make a large landscape tapestry. I have always enjoyed the in-between places or 'edgelands' as they have become fashionably known. The imaginary place I have depicted is not unlike the landscape of Essex where I lived as a young child. The layered quality of the image harks back to some of my earliest sketchbook paintings made whilst at art college. I was about half way through making this work when I realized I was unconsciously drawing a transcription of one of my favourite paintings, *Battle of Britain* by Paul Nash. Having yet again acknowledged the power of the uncon-

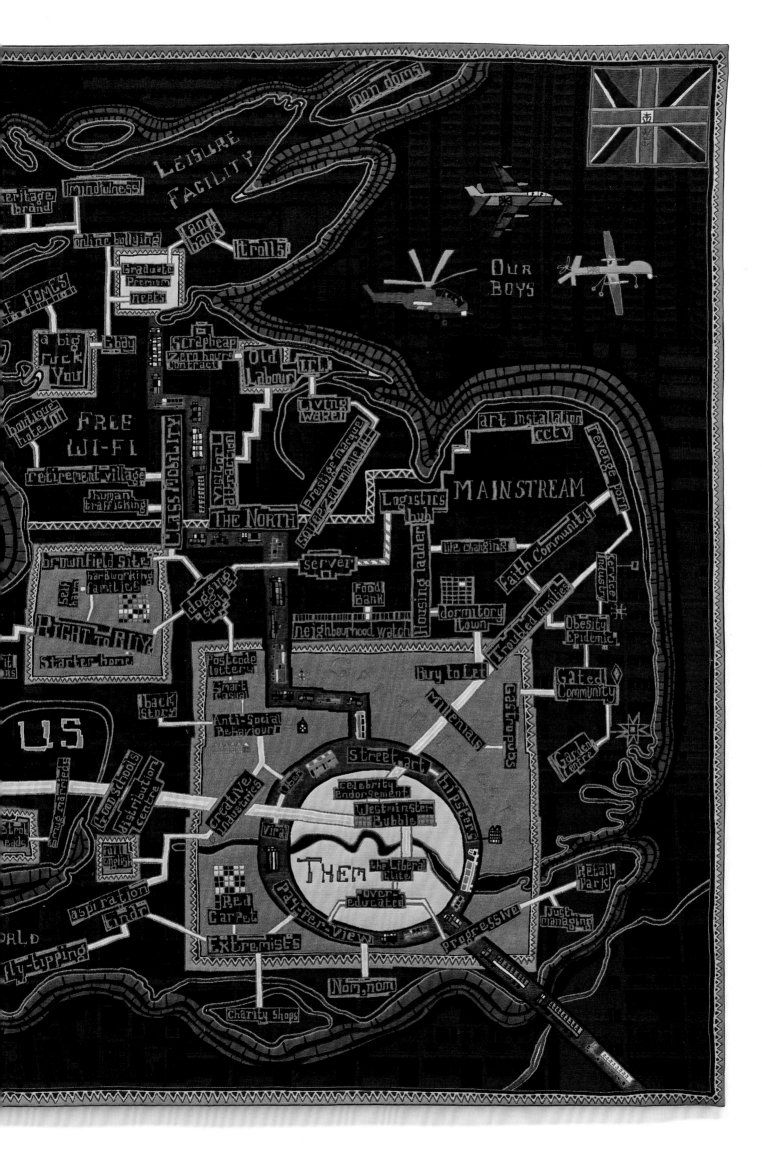

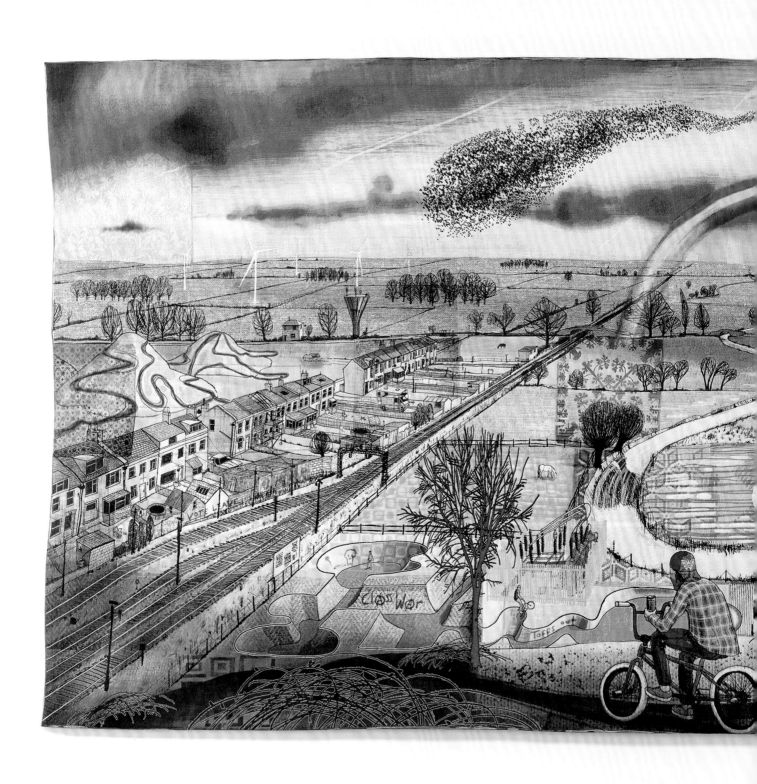

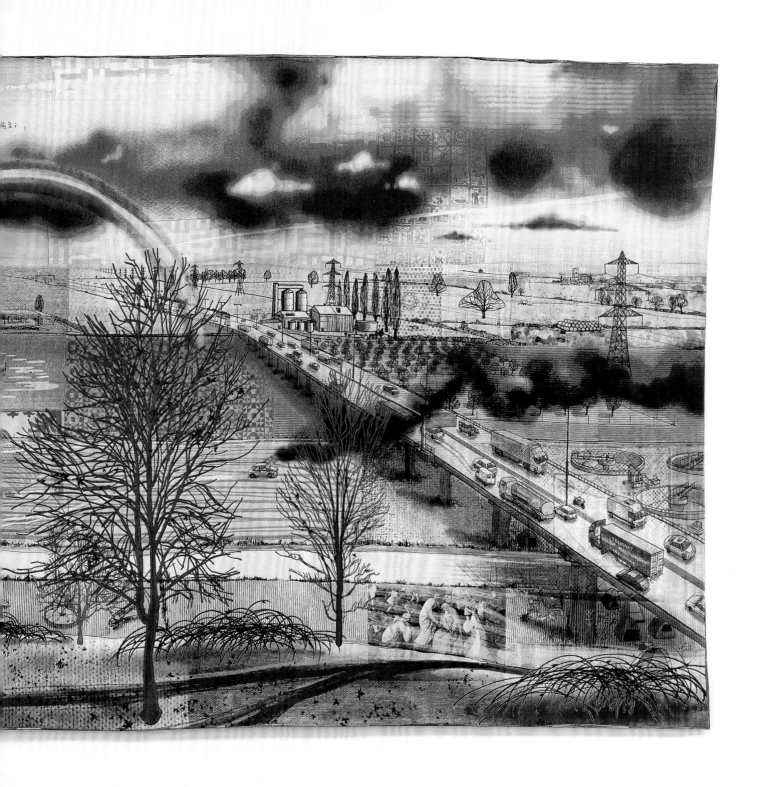

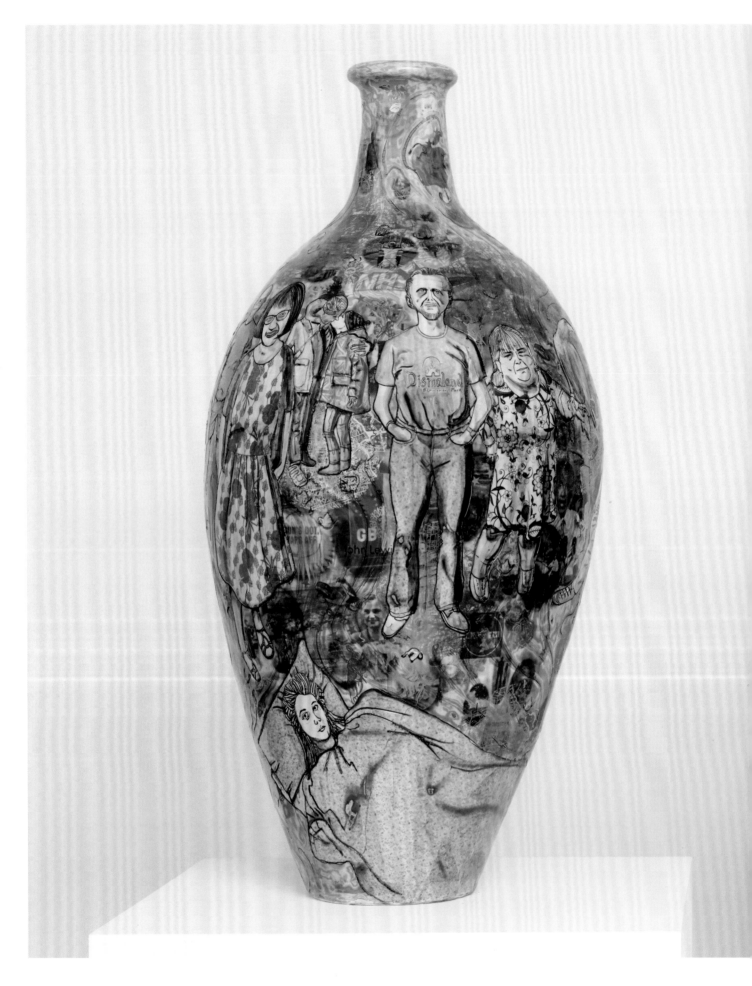

Matching Pair

I have always been wary of audience participation in art. Art is my job.
I put huge effort, hard-won skill and long experience into each piece.
I care deeply about the quality of my art – why would I want to
compromise that by allowing random strangers to affect the look of
what I do? Well, I thought it would be an interesting experiment to
make a work that involved, to use the fashionable term, crowdsourcing
via social media. Over the course of ten weeks I posted short videos
on Facebook and Twitter asking for contributions and feedback.

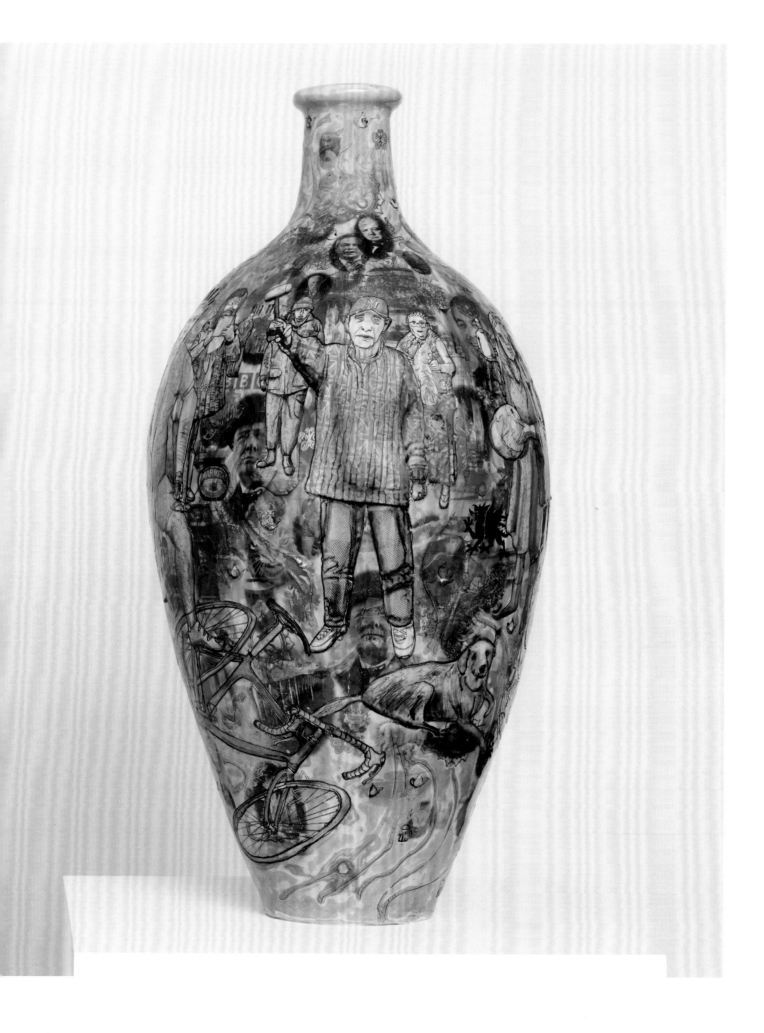

One pot features the images and choices of those that voted to leave
in the EU referendum, the other features the images and choices
of those that voted to remain. I asked for self-portrait photographs,
pictures of things people loved about Britain, their preferred colour,
favourite brands and who represented their values. The two pots
have come out looking remarkably similar, which is a good result,
for we all have much more in common than that which separates us.

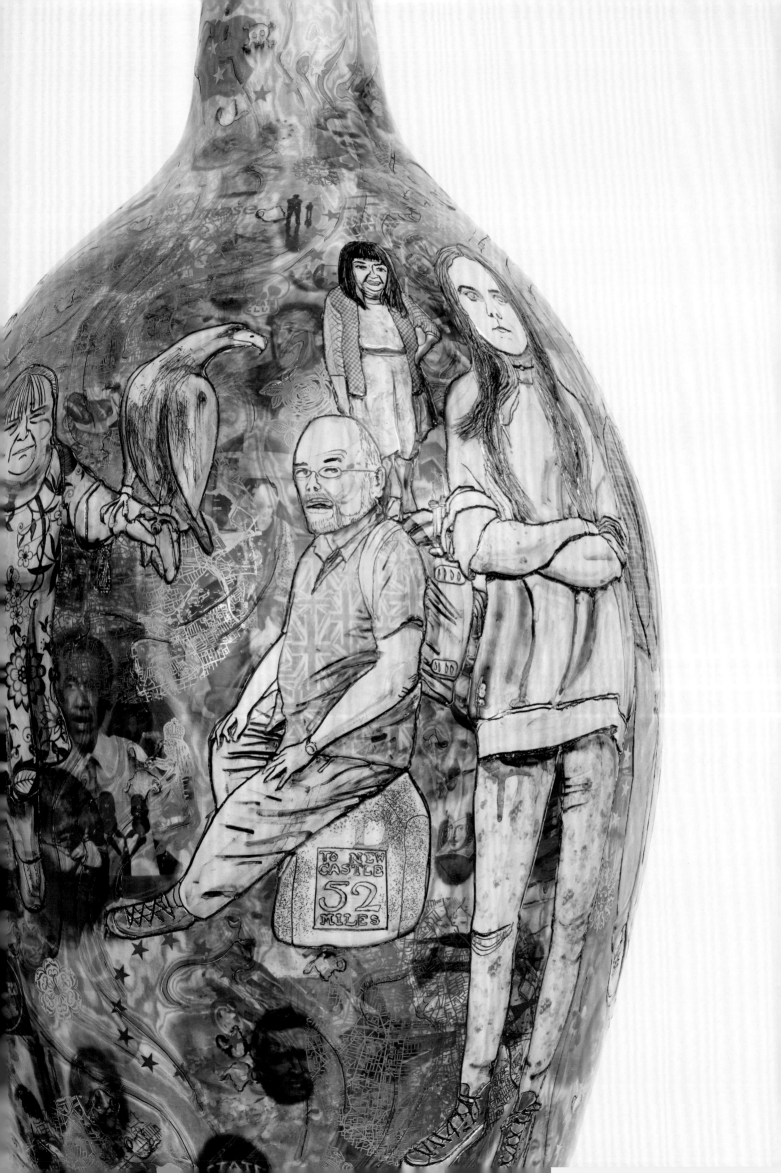

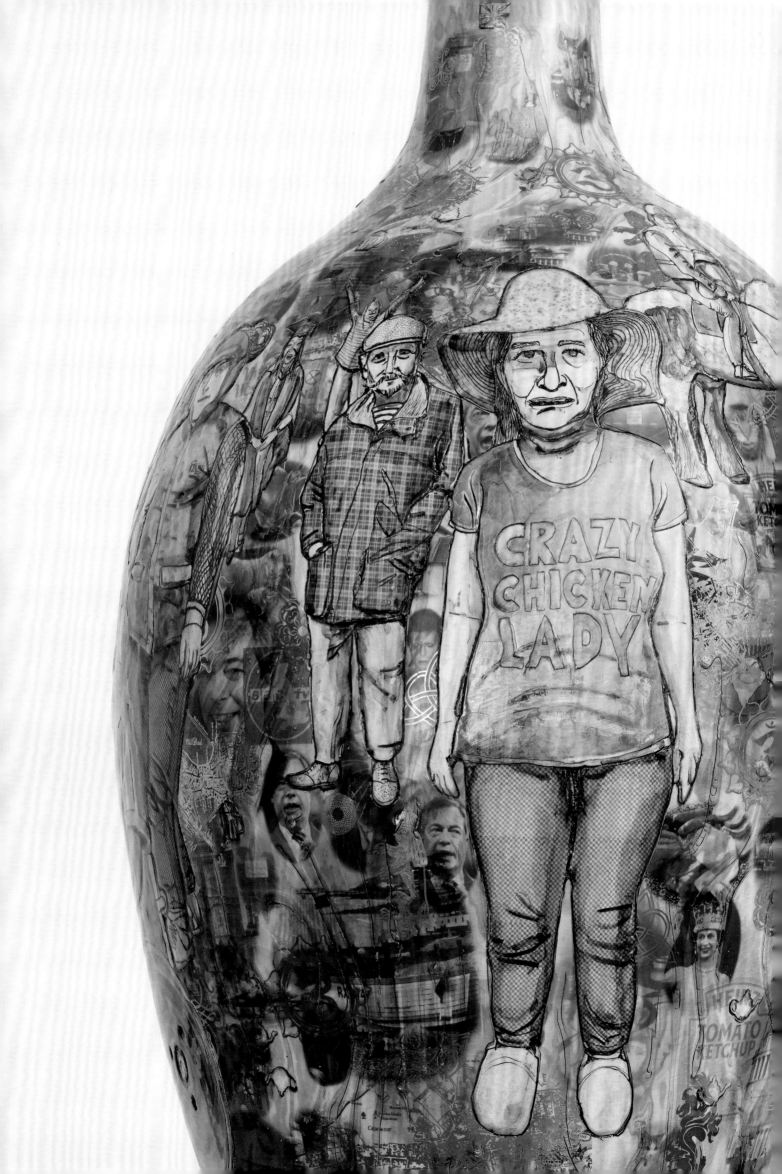

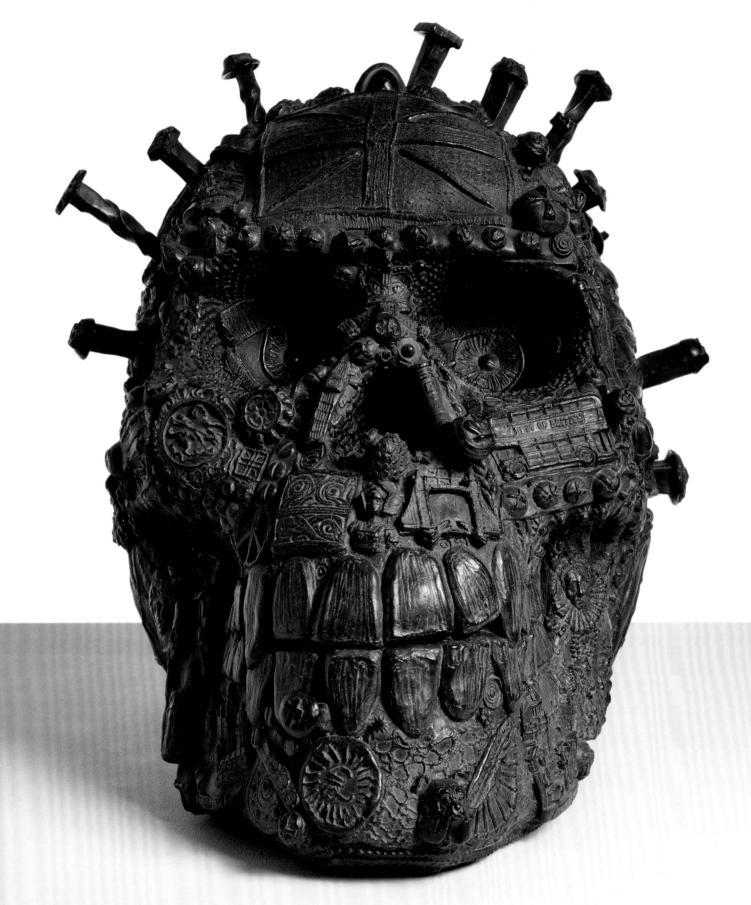

Head of a Fallen Giant

There has been much debate about what exactly
Englishness is. We struggle to define it. I wanted to
make something that looked like an ethnographic
artefact that was about England. At once mystical
and banal, this is the skull of a decaying maritime
superpower. Like a World War II mine washed up
on a beach encrusted with the boiled-down essence
of empire in the form of tourist tat.

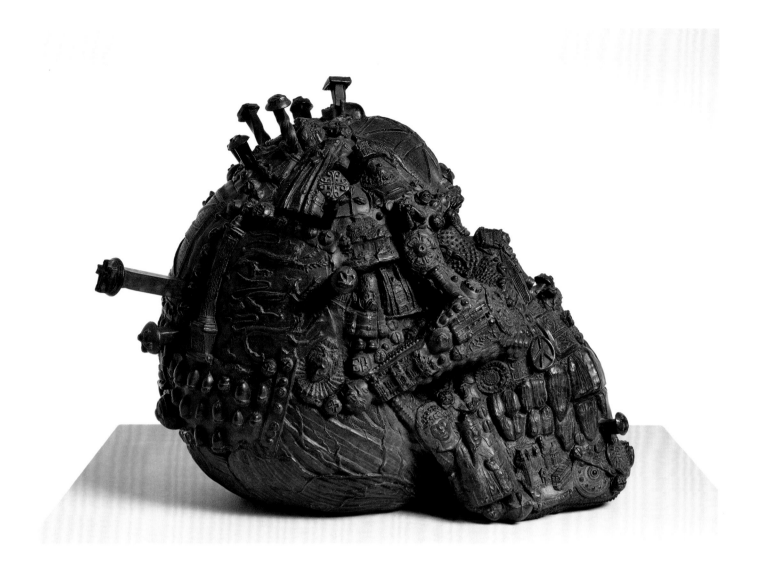

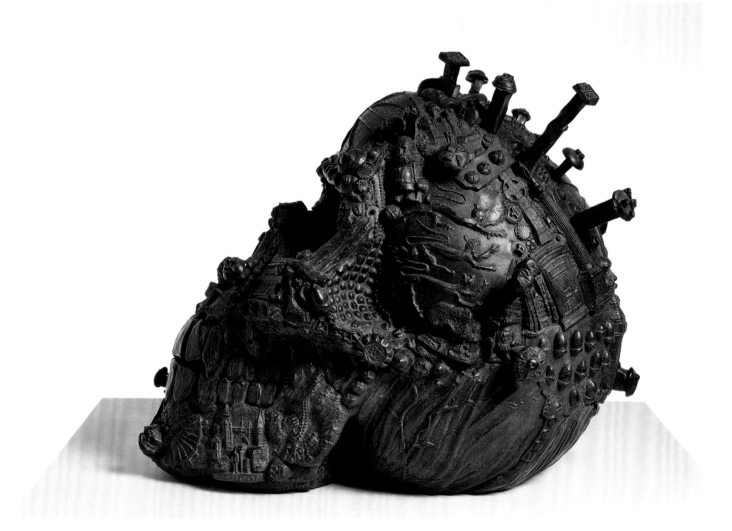

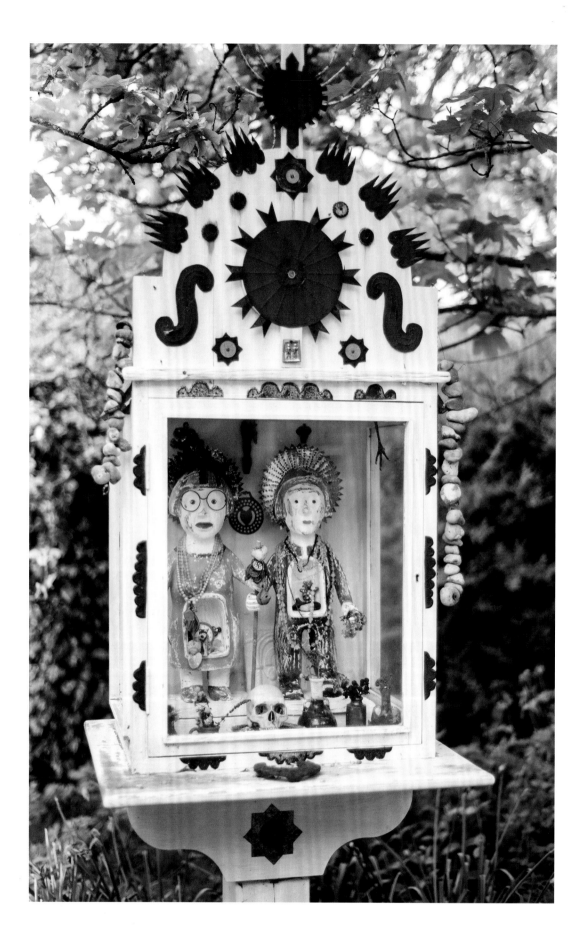

Marriage Shrine

One of my favourite books is on Lithuanian folk culture. It contains
several great photos of Christian roadside shrines made of wood. A
few years ago I commissioned a joiner to make me a similar one and
I have used it as a shrine to love. Britain is a majority secular society
and I feel we miss out on ritual. This shrine stands in our garden and
is my way of honouring my marriage to Philippa. In the stomach
cavity of the Grayson figure is the broken valve head of a BMW R90
motorcycle. Philippa and I spent one of our early dates pushing the
bike up the hard shoulder of the M11 in the rain. She regards it as one
of the most romantic evenings we have spent together! Inside the
Philippa figure is a piece of the clip that was attached to our
daughter's umbilical cord after it was cut.

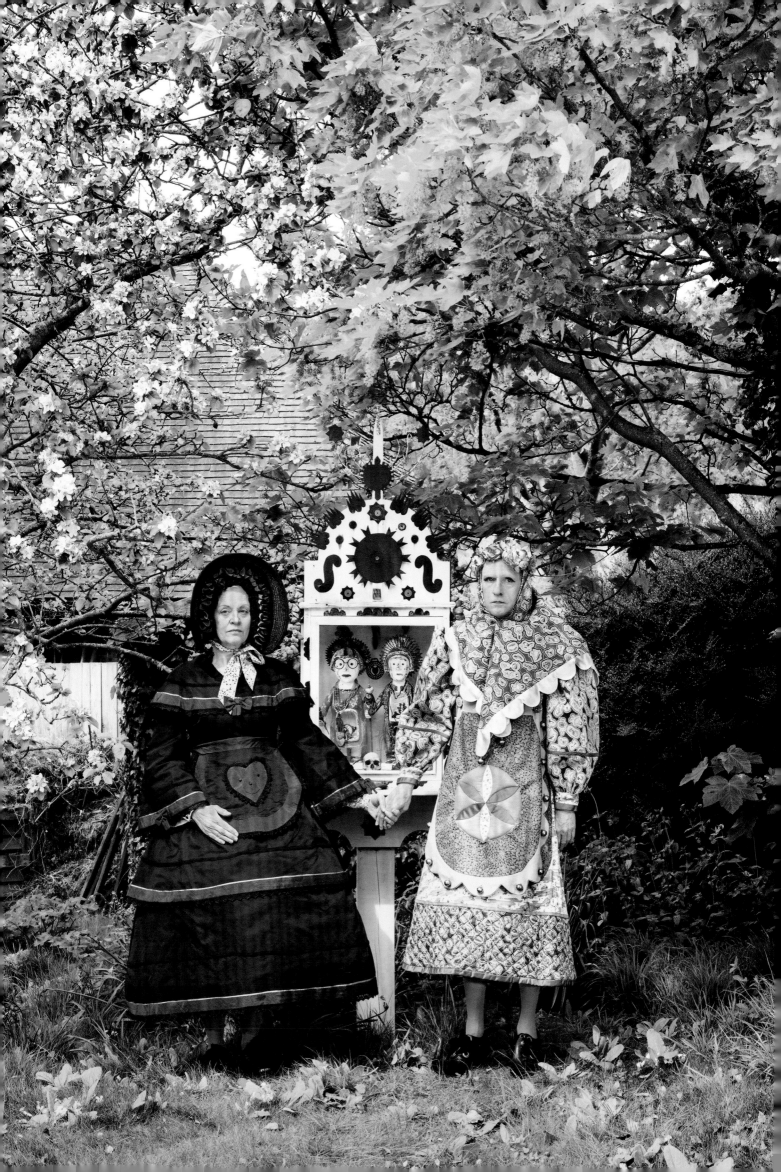

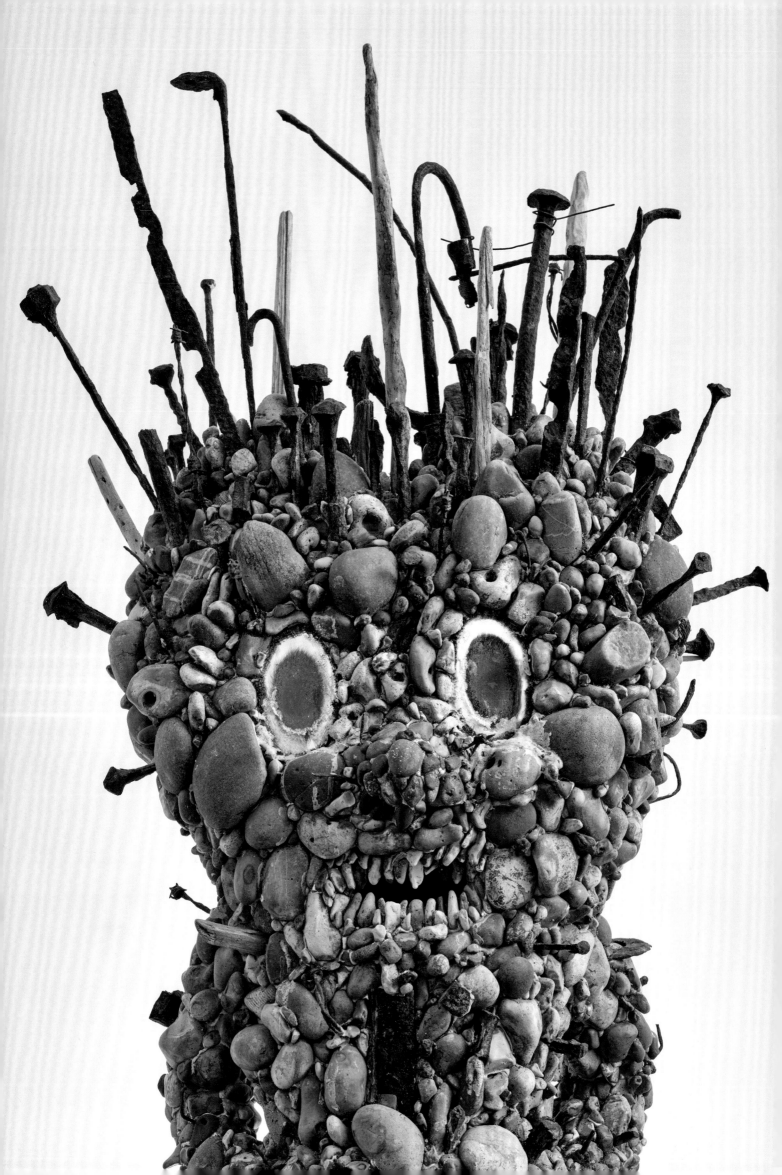

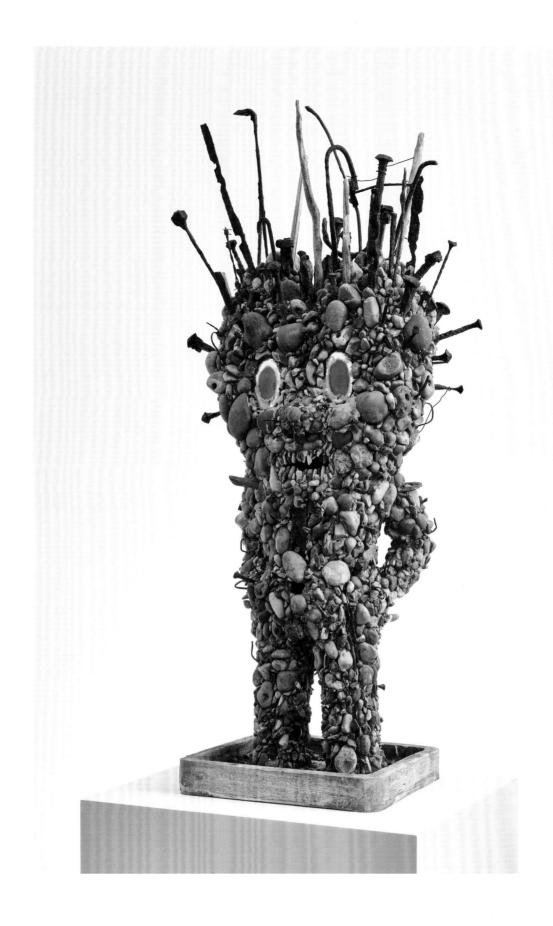

Outsider Alan

Alan Measles has featured in my work in many guises. Alan is my surrogate father and metaphor for God. Here he is a totemic figure made from pebbles and objects found on the beach. In making this work I was going back to how I made art when I first came to London and used whatever was lying around our squat. Outsider or folk artists often create imaginary worlds from scrap and junk. Alan was the benign dictator of my imaginary world as a child so it is fitting I have made him in the style of one of those spontaneous creators.

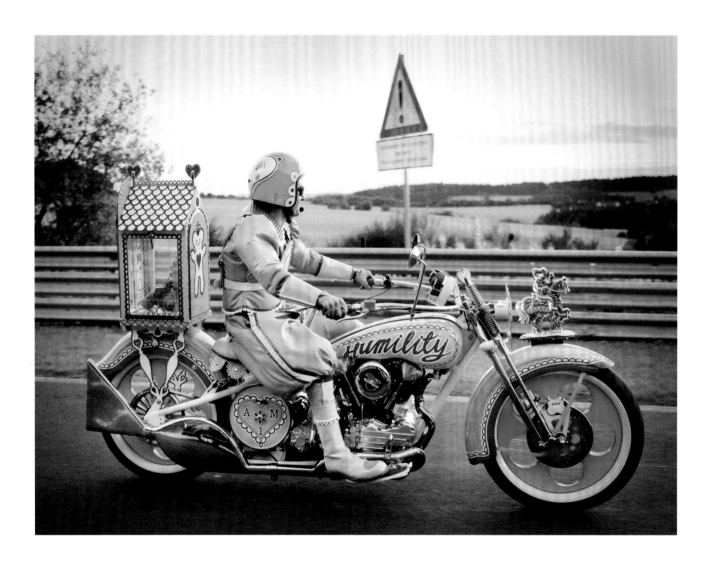

Kenilworth AM1

I have always loved custom motorcycles but have never had the skills to build one myself. When I could finally afford to commission one I got carried away and it became an artwork rather than a means of transport. I very much wanted other people to see Alan Measles as a god but he needed to go out amongst them, so the *Kenilworth AM1* was conceived. It is a kind of Popemobile for my teddy bear.

The AM1 was designed partly as a challenge to masculine stereotypes. It is a huge macho machine but instead of being festooned with skulls, flames and naked women it is childishly playful and pink and is emblazoned with words that I thought the antithesis of the death-defying biker stereotype: patience, humility and chastity. Recently one of my biker friends called it a 'carbuncle', but I included it in this show because it is a popular work, particularly with men.

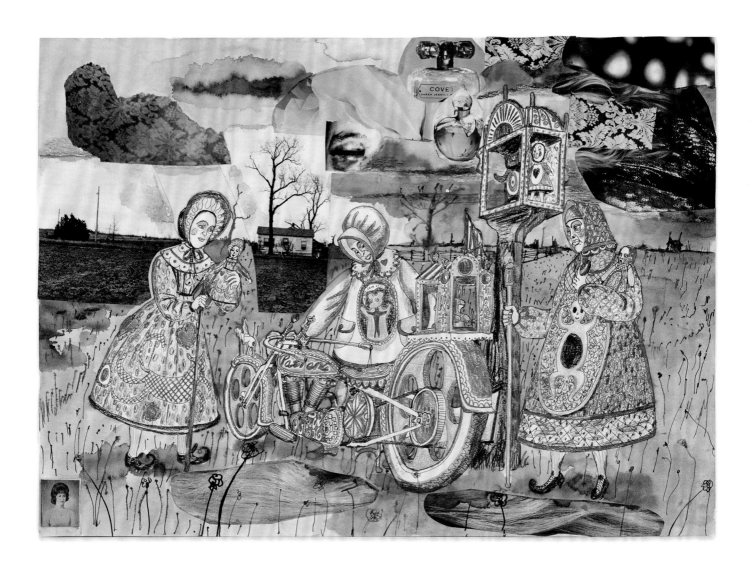

Stopping at a Roadside Shrine

I made this image when I was fantasising about where I might ride the AM1 before it was built. I imagined embarking on a journey through a Ruritanian folk culture. This seed of an idea developed into *The Ten Days of Alan* when in 2010 I rode the AM1 through Germany visiting various cultural sites including the Neuschwanstein castle which featured in the film *Chitty Chitty Bang Bang*.

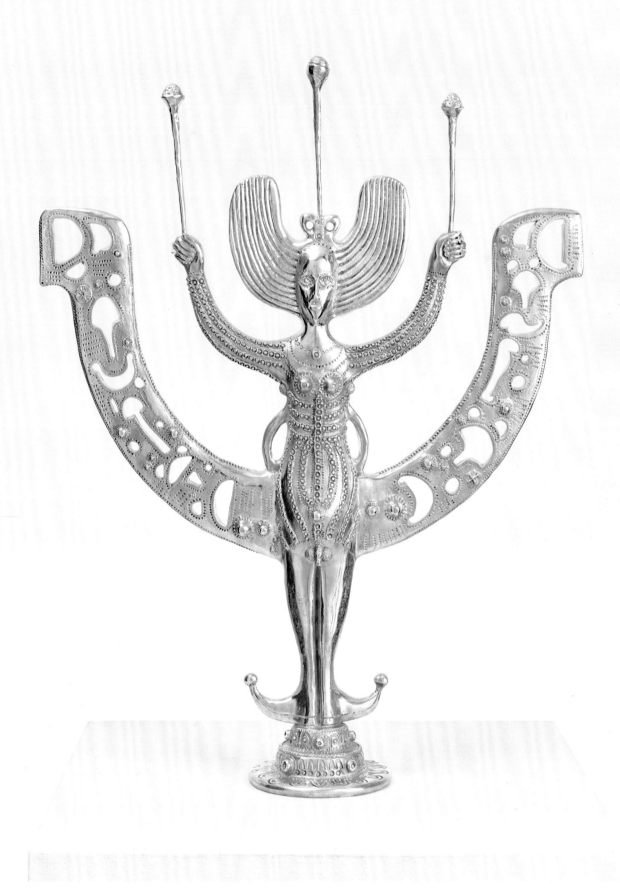

Princess Freedom

Princess Freedom is the solid silver sculpture on the front of a new
bicycle I have commissioned for the exhibition. I think of her as
a repurposed folk artefact. She seems to have echoes of older
traditional cultures. Who is this hermaphrodite figure? She looks
vaguely functional, but what was she for? She must be old but she
seems to chime with contemporary issues on gender and equality,
and she is being carried in state, honoured by a bicycle, the vehicle
that gave women freedom over a century ago and that is proving
central to modern urban living.

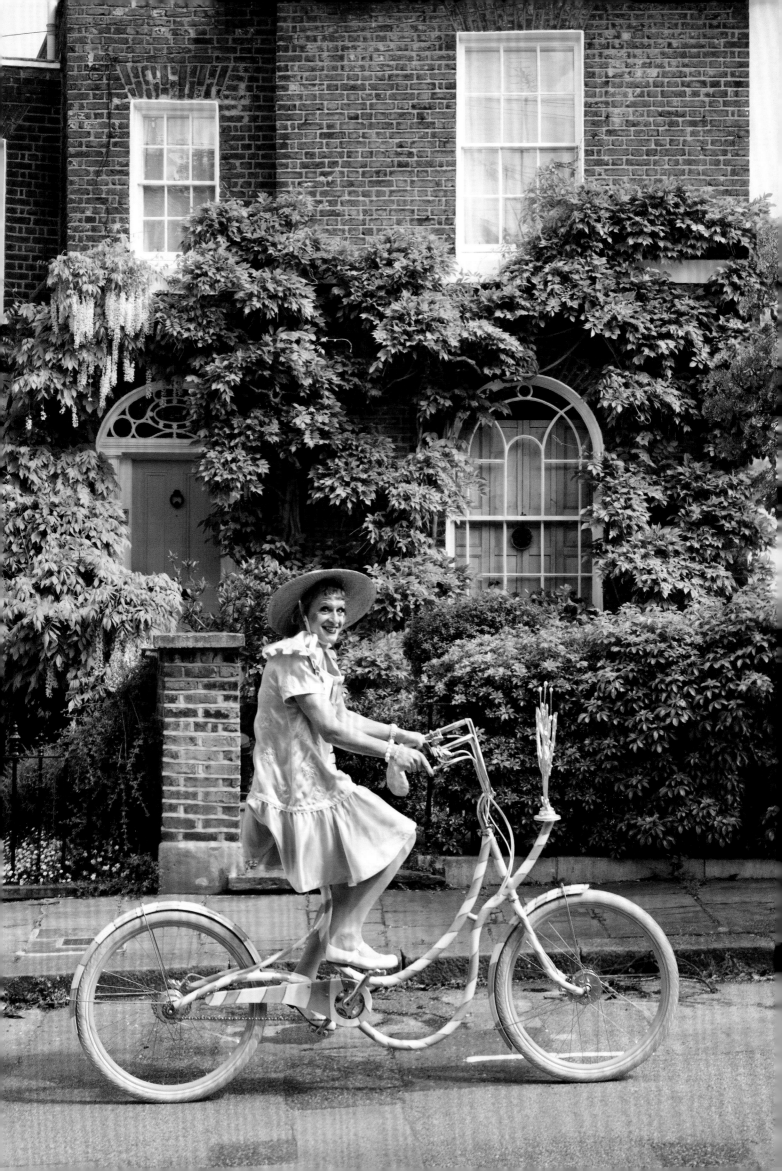

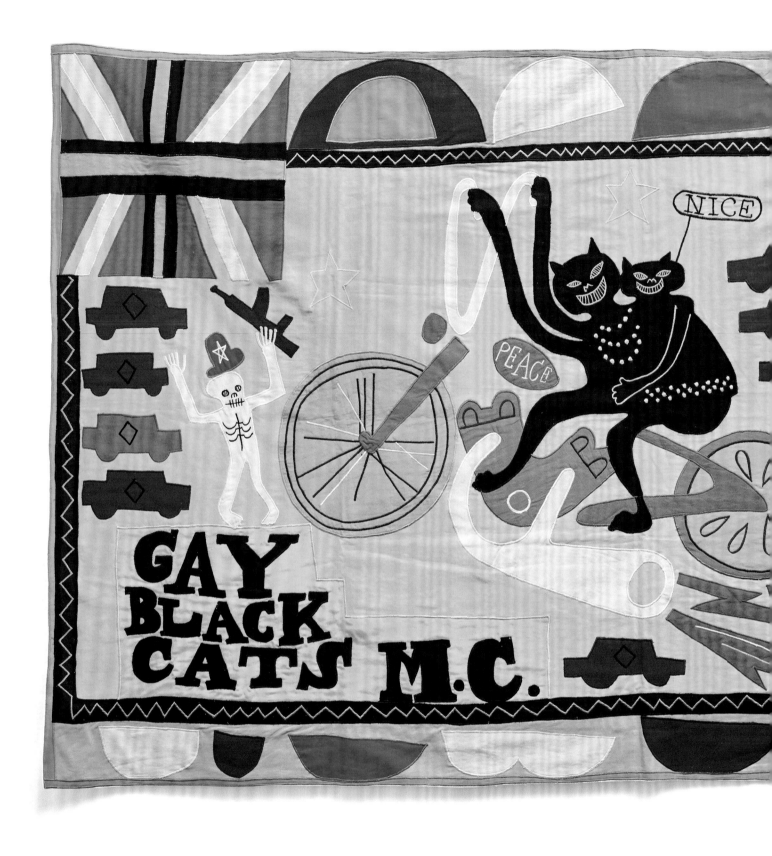

Gay Black Cats MC

This is my homage to one of my favourite groups of artefacts – Asafo flags. In the 1600s the Fante people of the Gold Coast (now modern day Ghana) set up military groups called Asafo. The Asafo adopted some European military practices, including the display of a Company flag. In a curious twist Lord Baden-Powell is thought to have been influenced by the Asafo when setting up the Scouting movement. Asafo flags often feature images that are designed to taunt rivals. This flag is one I have designed for an imaginary motorcycle gang.

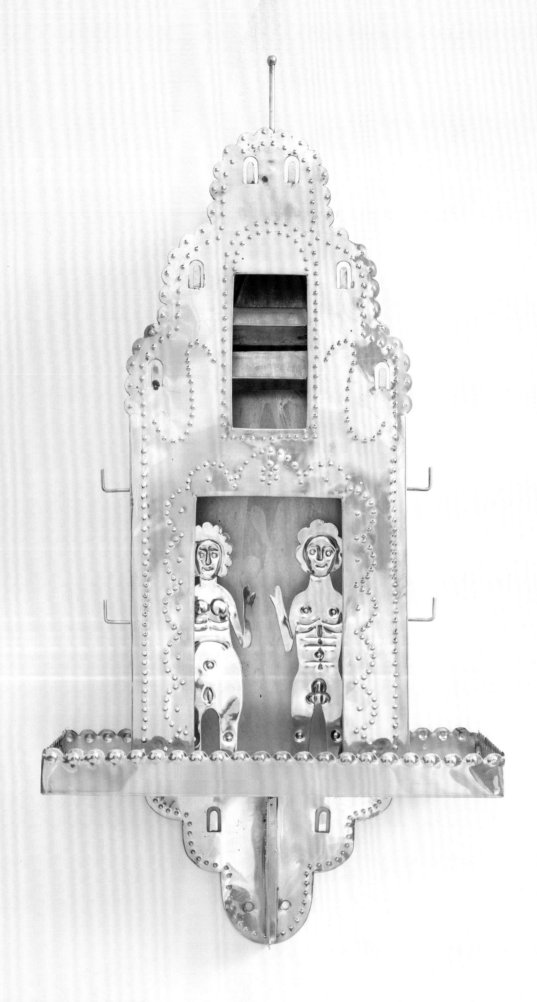

House of Love

I have designed this small brass shrine so that people
can set up a place in their own home or garden to
celebrate their loving partnership. The figures can be
purchased separately so any configuration of genders
can be honoured. I hope that people feel they can
decorate the shrine to make it their own with candles,
keepsakes, photos, trinkets or offerings. It is a piece to
keep and build on over a long relationship.

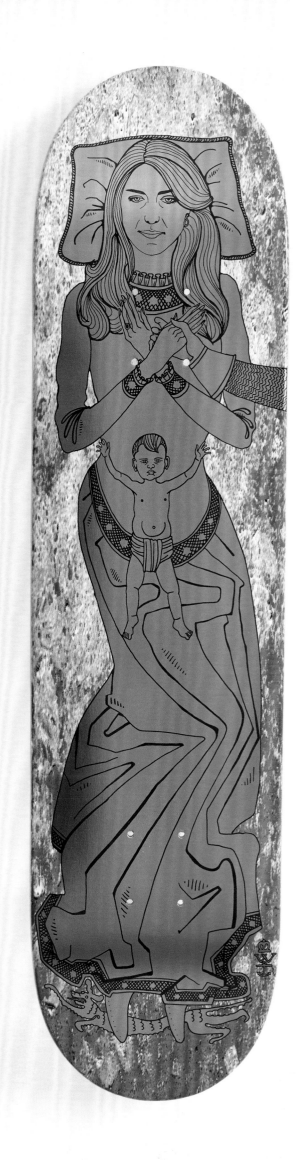

Kateboard

I was a keen skateboarder for ten years or so when I was young. In the 1980s skateboarding aligned itself with punk and played up its outlaw credentials – skating in illegal spots, graffiti, thrash metal bands. Only a whiff of that edginess still clings to the sport. So when I was asked by The Skateroom to design a board I was very aware of the social context of any image I were to place on one. The Skateroom collaborates with artists on deck designs and the profits go on to help finance social projects. This combination of waning street credibility and doing 'good works' seemed to slip in easily amongst the themes of this exhibition. The image is the Duchess of Cambridge in the form of a monumental church brass. She is a popular figure who does good works and a church brass might be the only context where we would get to stand on top of a member of the Royal Family.

List of Works

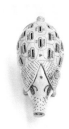

Long Pig, 2017
Glazed ceramic
39 x 32 x 82 cm

Courtesy the artist and
Victoria Miro, London

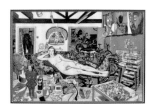

Reclining Artist, 2017
Woodcut printed on 315gsm Heritage
White
Sheet size: 195 x 294 cm
Edition of 12 plus 2 artist's proofs

Published by Paragon
Courtesy the artist, Paragon |
Contemporary Editions Ltd
and Victoria Miro, London

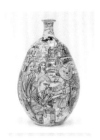

*Alan Measles and Claire
Visit the Rust Belt*, 2017
Glazed ceramic
56 x 36 cm

Courtesy the artist and
Victoria Miro, London

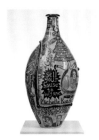

Puff Piece, 2016
Glazed ceramic
74 x 34 cm

Courtesy the artist and
Victoria Miro, London

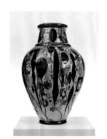

Visitor Figures, 2016
Glazed ceramic
79 x 50 cm

Courtesy the artist and
Victoria Miro, London

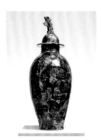

Shadow Boxing, 2016
Glazed ceramic
95 x 38 cm

Private collection

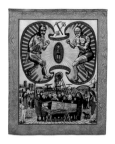

Death of a Working Hero, 2016
Tapestry
250 x 200 cm
Edition of 6 plus 2 artist's proofs

Published by Paragon
Courtesy the artist, Paragon |
Contemporary Editions Ltd
and Victoria Miro, London

The Digmoor Tapestry, 2016
Tapestry
215 x 265 cm
Edition of 6 plus 2 artist's proofs

Published by Paragon
Courtesy the artist, Paragon |
Contemporary Editions Ltd
and Victoria Miro, London

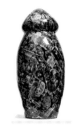

King of Nowhere, 2015
Cast iron and mixed media
89 x 44 x 42 cm
Edition of 5 plus 1 artist's proof

Courtesy the artist and
Victoria Miro, London

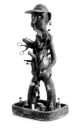

Object in Foreground, 2016
Glazed ceramic
68 x 38 cm

Courtesy the artist and
Victoria Miro, London

Animal Spirit, 2016
Woodcut printed on
315gsm Heritage White
Sheet size: 194 x 242.5 cm
Edition of 21 plus 2 artist's proofs

Published by Paragon
Courtesy the artist, Paragon |
Contemporary Editions Ltd
and Victoria Miro, London

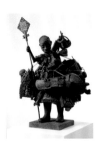

Our Mother, 2009
Cast iron, oil paint, string and cloth
84.5 x 65 x 65 cm
Edition of 5 plus 1 artist's proof

Courtesy the artist and
Victoria Miro, London

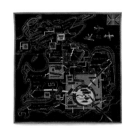

Red Carpet, 2017
Tapestry
247 x 252 cm
Edition of 8 plus 2 artist's proofs

Published by Paragon
Courtesy the artist, Paragon |
Contemporary Editions Ltd
and Victoria Miro, London

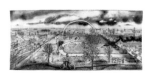

Battle of Britain, 2017
Tapestry
302.7 x 701 cm
Edition of 10 plus 2 artist's proofs

Published by Paragon
Courtesy the artist, Paragon |
Contemporary Editions Ltd
and Victoria Miro, London

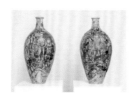

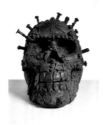

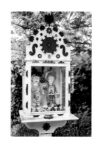

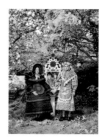

Matching Pair, 2017
Glazed ceramic
Diptych
Each: 105 x 51 cm

Courtesy the artist and
Victoria Miro, London

Head of a Fallen Giant, 2008
Bronze
40 x 50 x 35 cm
Edition of 5 plus 1 artist's proof

Courtesy the artist and
Victoria Miro, London

Marriage Shrine, 2017
Mixed media, wood, glass
165 x 67 x 65.7 cm

Collection of the artist

Couple Visiting Marriage Shrine, 2017
C-type print
75 x 50 cm

Collection of the artist

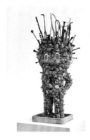

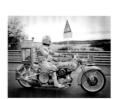

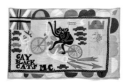

Outsider Alan, 2017
Ceramic, found objects, pebbles,
shells, iron, wood, glass
120 x 56 x 32 cm

Courtesy the artist and
Victoria Miro, London

Kenilworth AM1, 2010
Custom-built motorcycle
159 x 275 x 126 cm

Collection of the artist

Stopping at a Roadside Shrine, 2010
Watercolour, ink and collage on paper
41.9 x 59 cm

Collection of the artist

Gay Black Cats MC, 2017
Cotton fabric and embroidery appliqué
97 x 148 cm
Edition of 150 plus 10 artist's proofs

Courtesy the artist

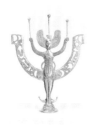

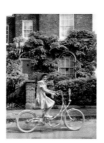

Princess Freedom, 2017
Cast silver
52 x 40.5 x 11.1 cm
Edition of 10 plus 2 artist's proofs

Courtesy the artist and
Victoria Miro, London

Princess Freedom Bicycle, 2017
Custom-built bicycle
255 x 154 x 69 cm

Collection of the artist

House of Love, 2017
Brass
60 x 30 x 17.5 cm
Edition of 20 plus 2 artist's proofs

Courtesy the artist

Kateboard, 2017
Skateboard
80 x 20 x 14 cm
Edition of 999 plus 25 artist's proofs

Published by The Skateroom

Courtesy the artist